THE ENCHANTED LANDSCAPE

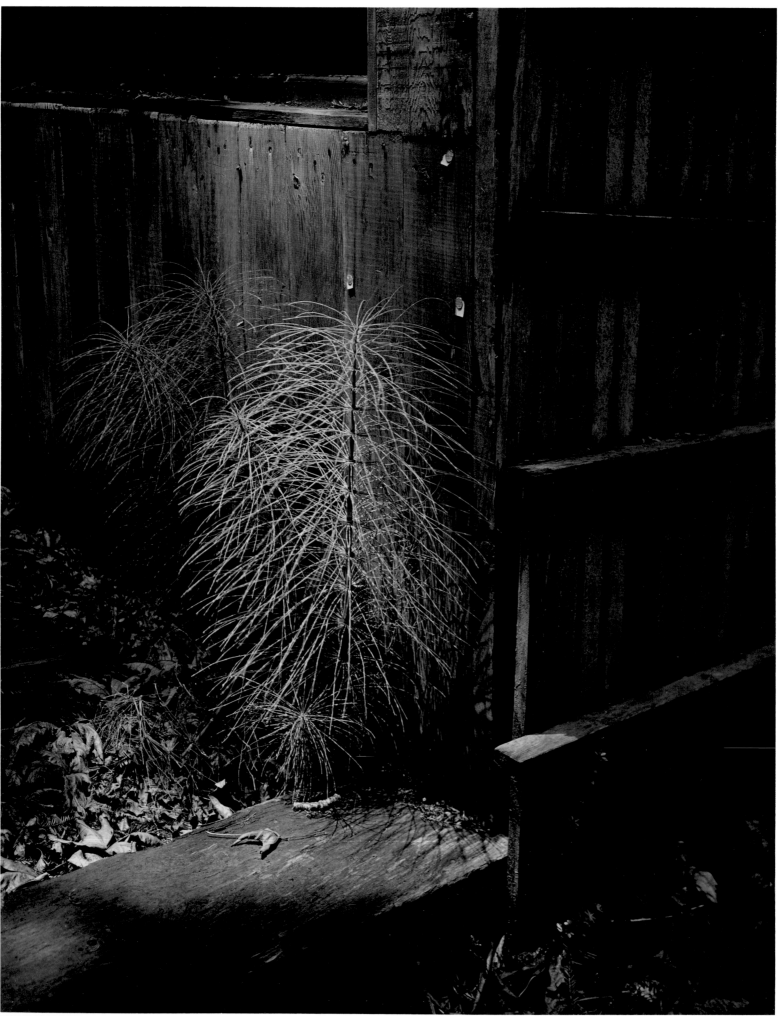

THE HORSETAIL, 1957

Wynn Bullock

THE ENCHANTED LANDSCAPE
PHOTOGRAPHS 1940-1975

POEM BY
URSULA K. LE GUIN

BIOGRAPHICAL ESSAY BY
RAPHAEL SHEVELEV

EXCERPTS FROM THE WRITINGS OF
WYNN BULLOCK

AN APERTURE BOOK

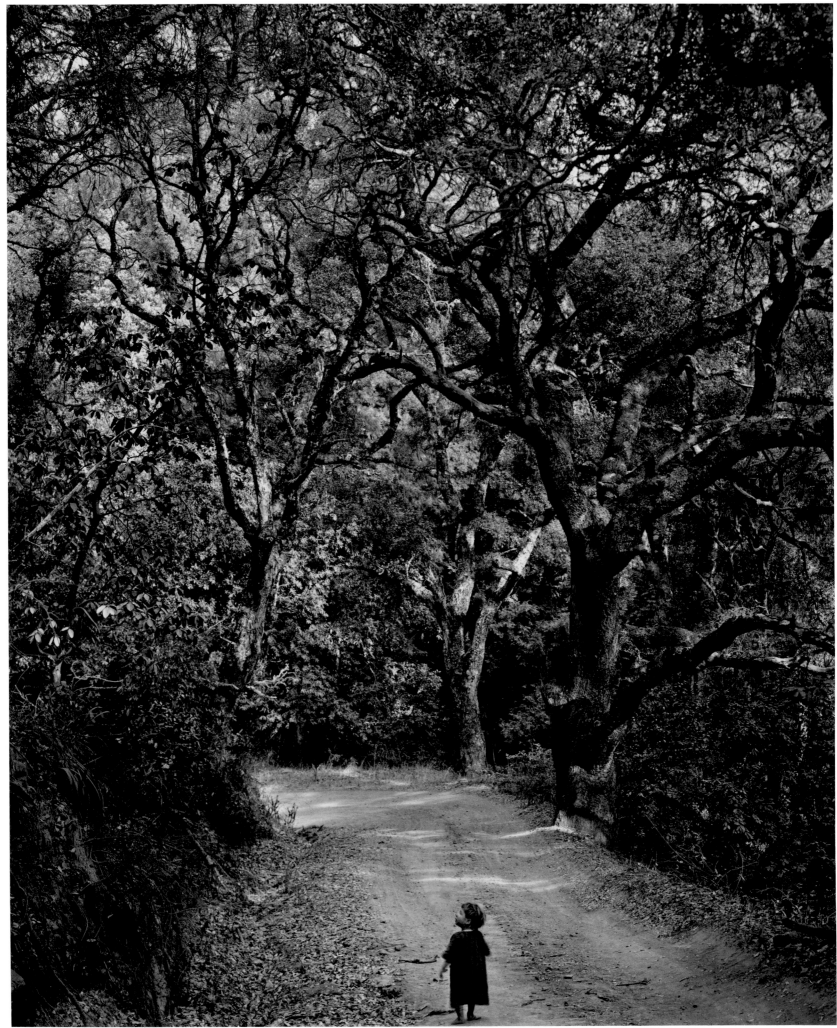

CHILD ON FOREST ROAD, 1958

"CHILD ON FOREST ROAD"

BY URSULA K. LE GUIN

*Where's the little one going
alone on the oak-forest road?
What does the child hear?*

*Maybe she's going to meet
the woman coming from there.*

*She's old, she's old,
her feet are bare,
her hair uncombed.
Far in the forest
and sweet she whistles,
"I'm coming, little one, little one,
coming on home."*

*Her feet are bare,
her hair uncombed,
the child who stops and listens, listens,
all by herself on the oak-forest road.*

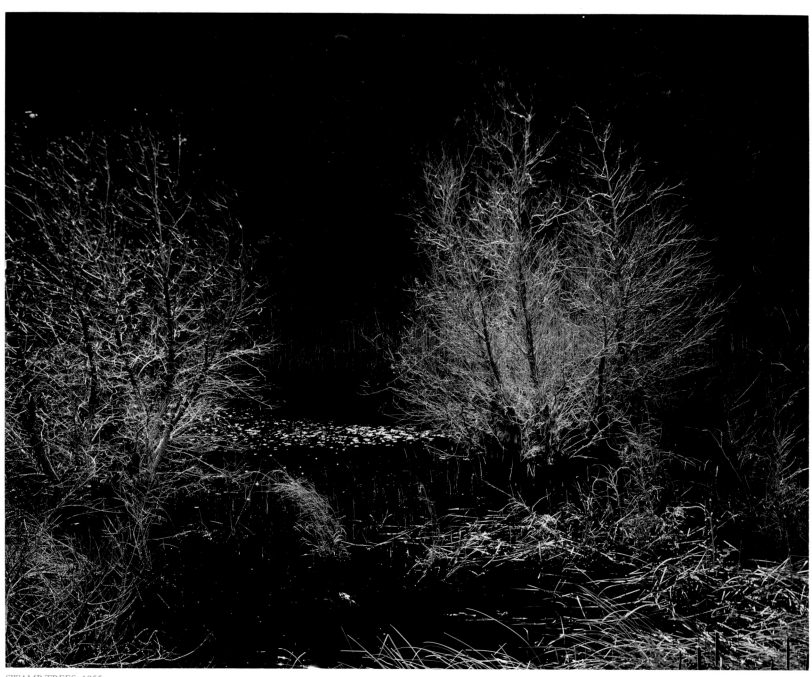

SWAMP TREES, 1955

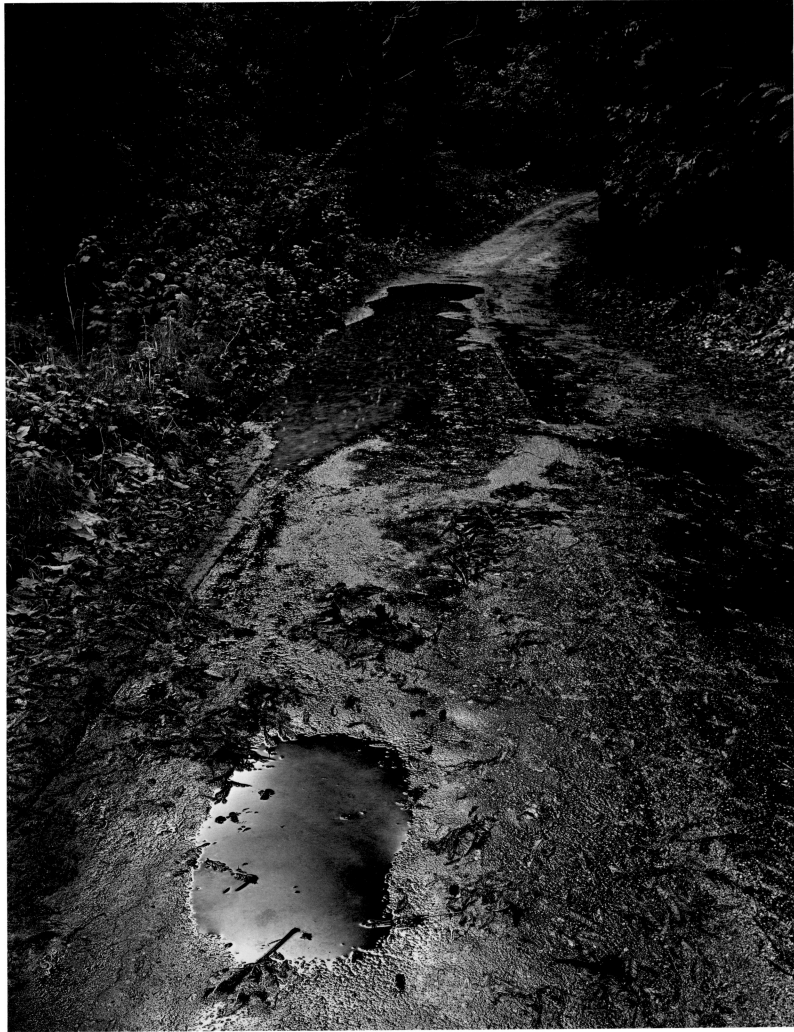

PALO COLORADO ROAD, 1952

Light is the source of everything.
It is what makes things visible to the eye.
It is also what holds a rock together.
My thinking has been deeply affected by
the belief that all things are some form
of radiant energy. Light is perhaps the
most profound truth in the universe.

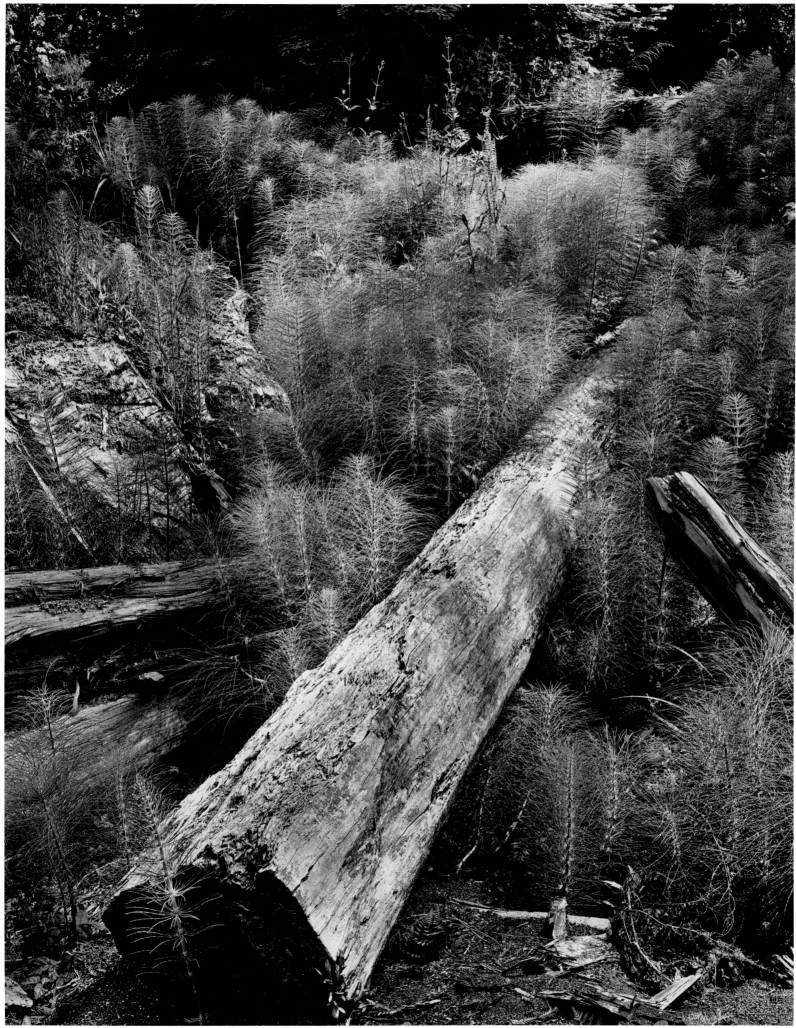

LOG AND HORSETAILS, 1957

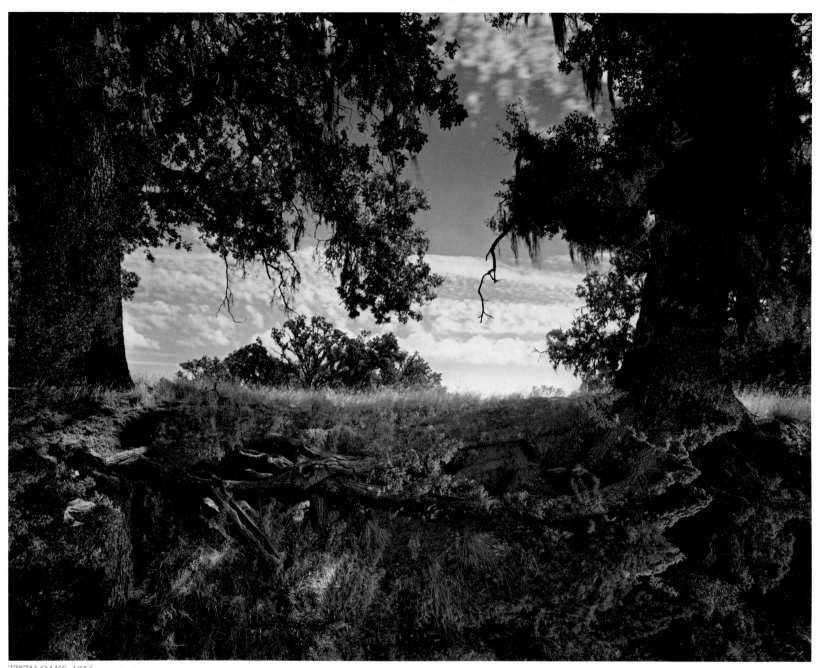

TWIN OAKS, 1956

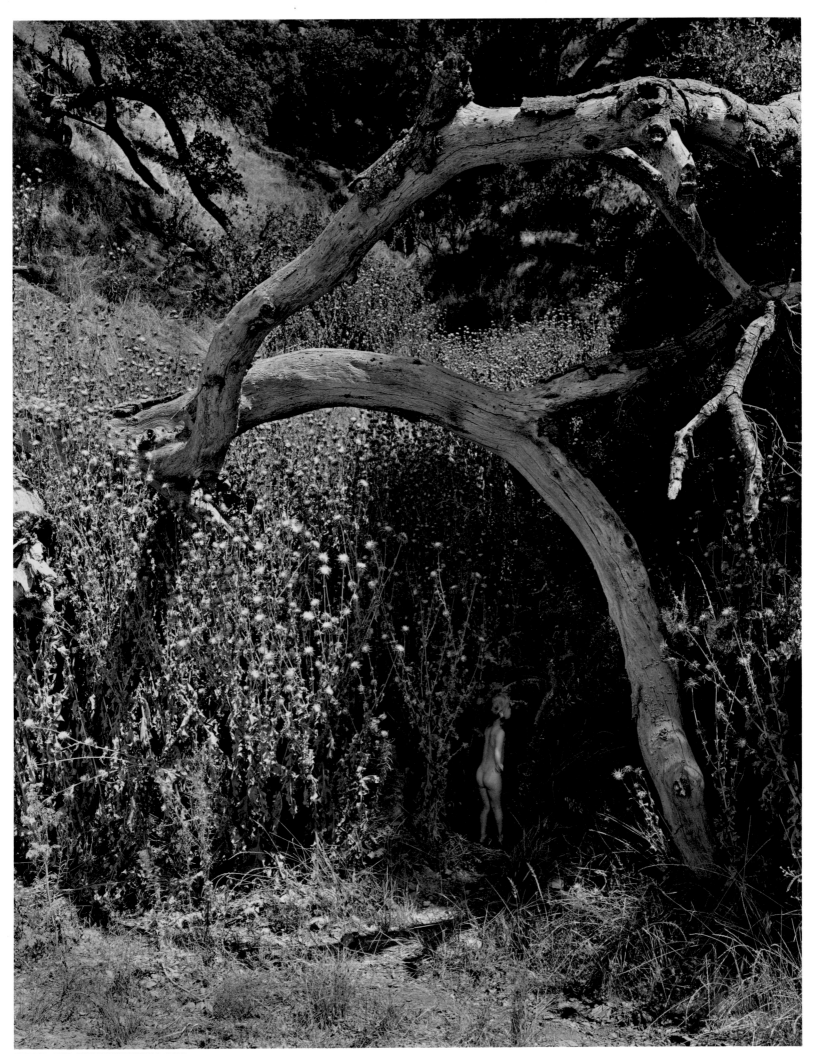

CHILD AND THE UNKNOWN, 1955

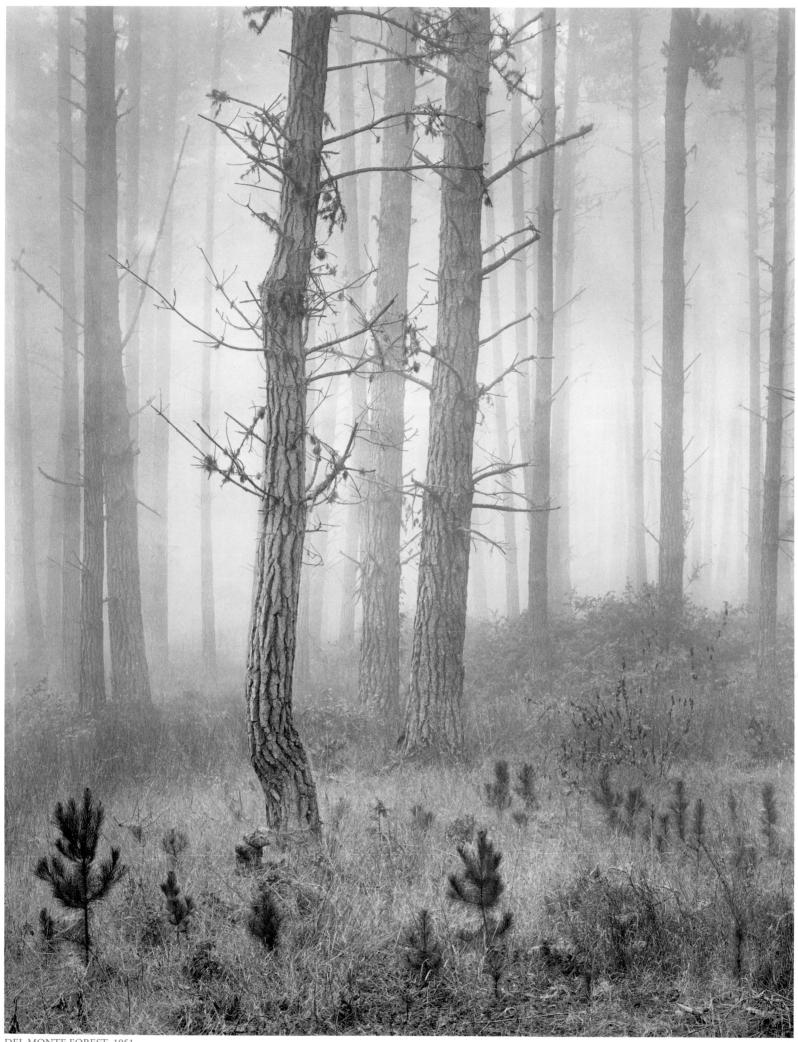

DEL MONTE FOREST, 1951

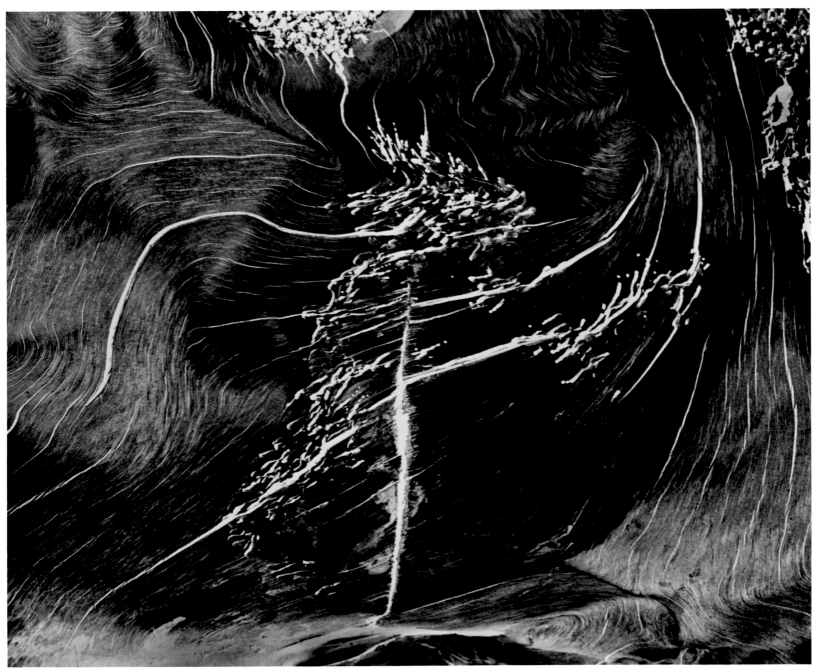

UNTITLED #13, 1972

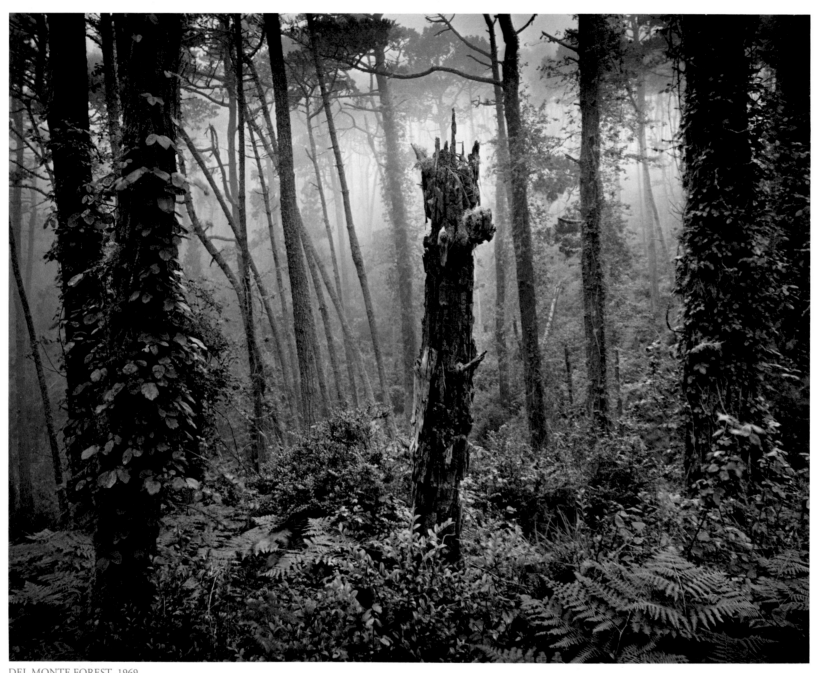

DEL MONTE FOREST, 1969

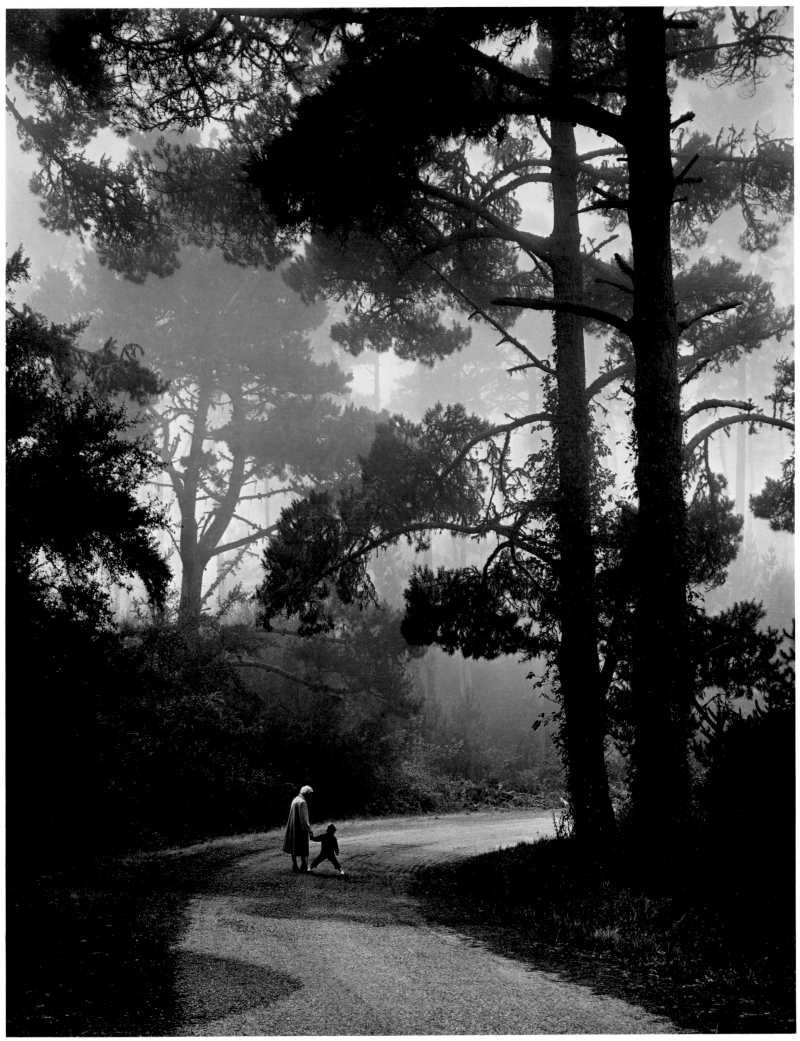

LYNNE AND GRANDMOTHER, 1956

How can you expand unless you search beyond what you are at the moment? To me, searching is everything. I speak not as an artist, a physicist, or a churchgoer, but as a human being seeking meaning. If a person stops searching, he stops living. Everything is a miracle, including ourselves.

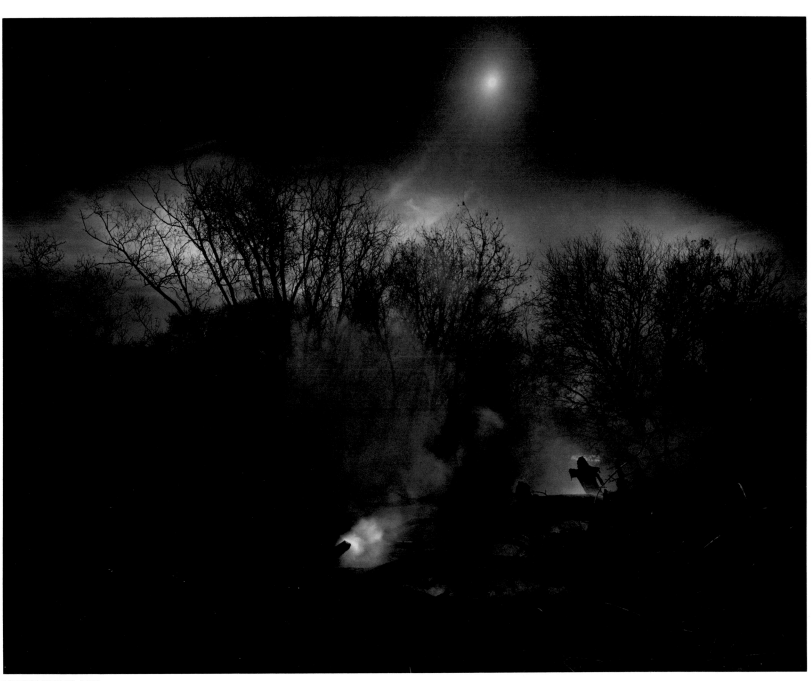

NIGHT SCENE, 1959

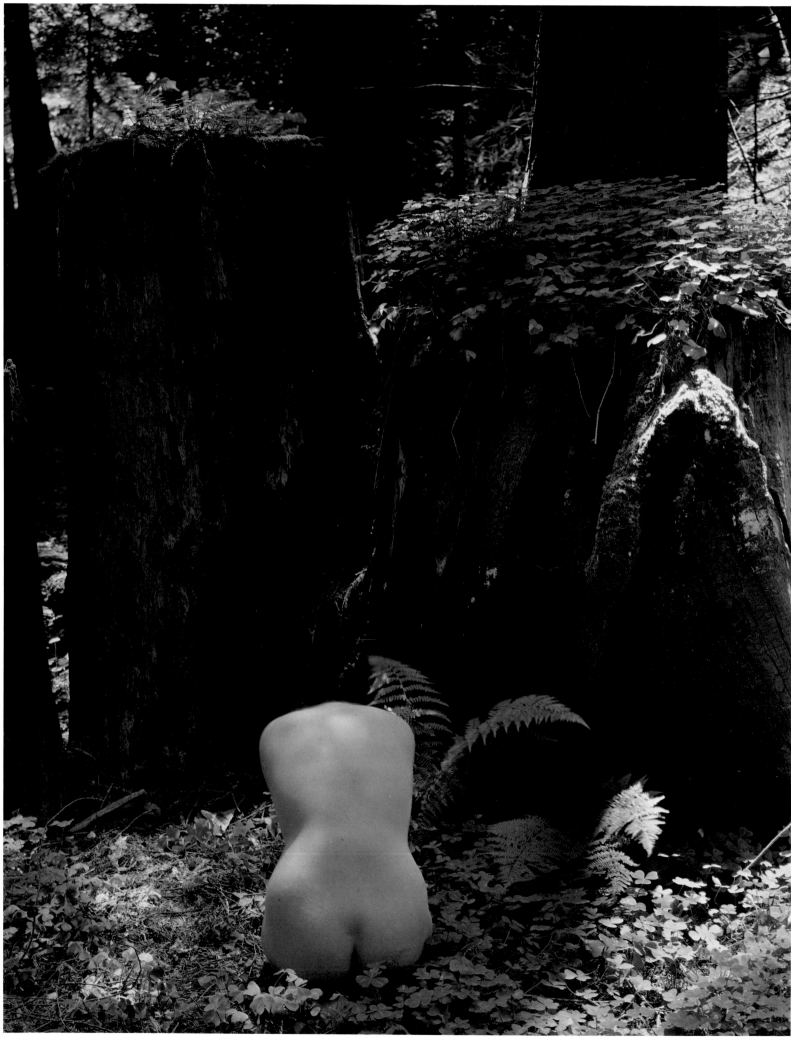

BARBARA, 1958

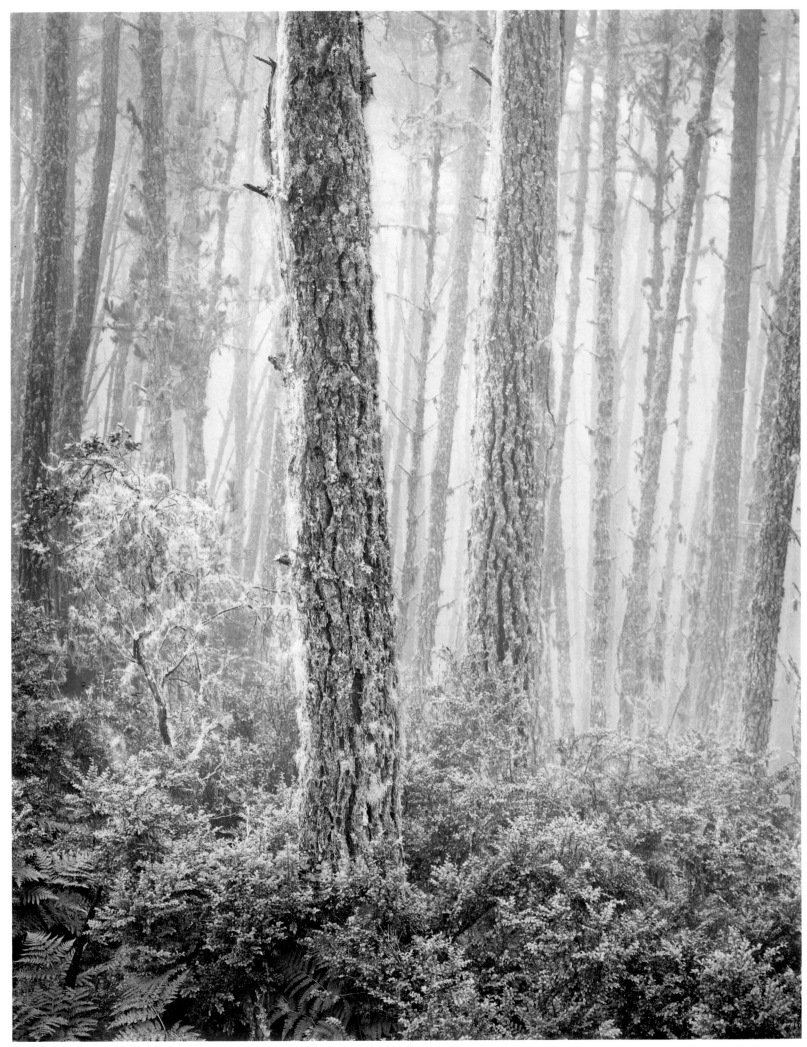

DEL MONTE FOREST, 1956

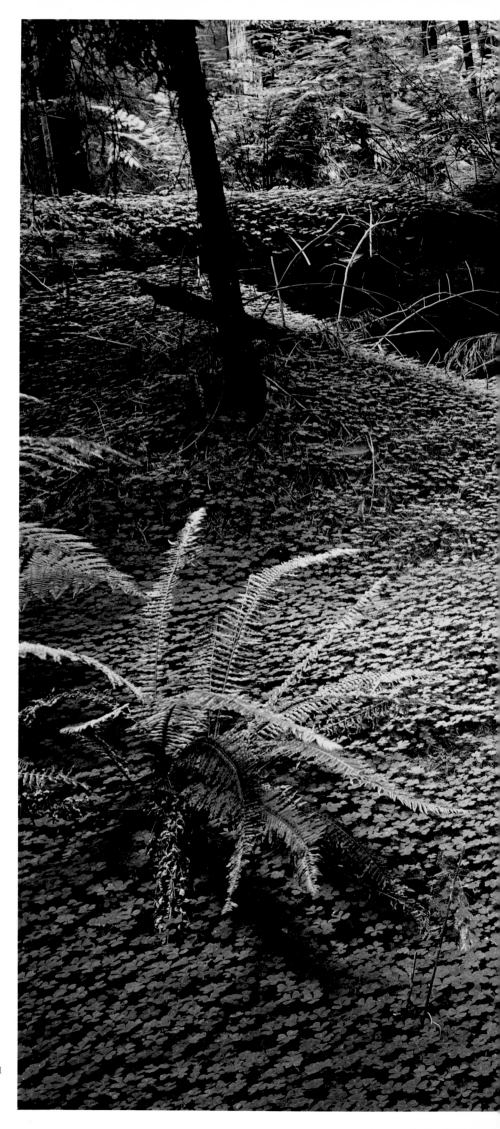

CHILD IN FOREST, 1951

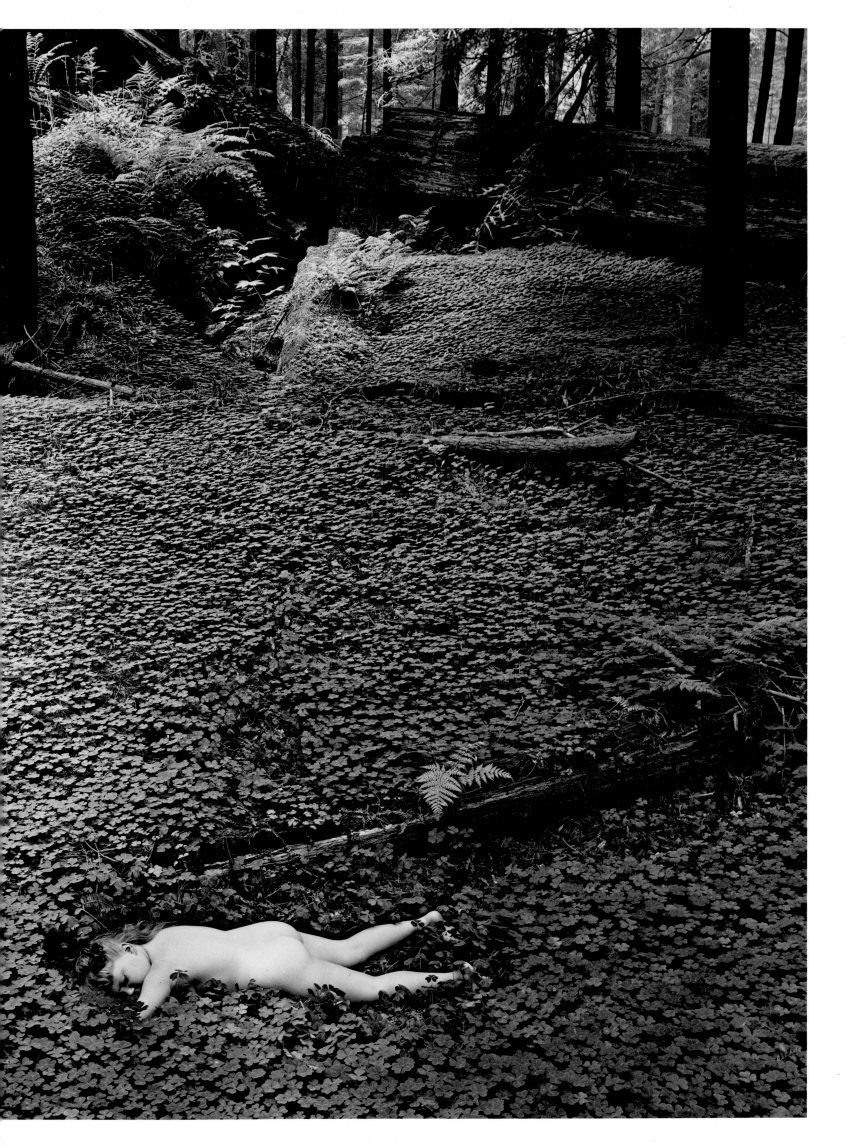

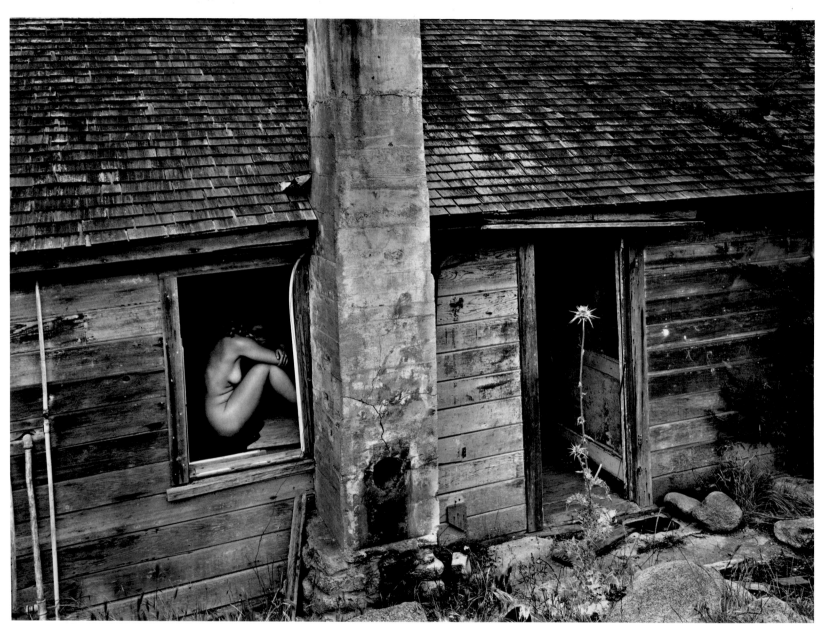

WOMAN AND THISTLE, 1953

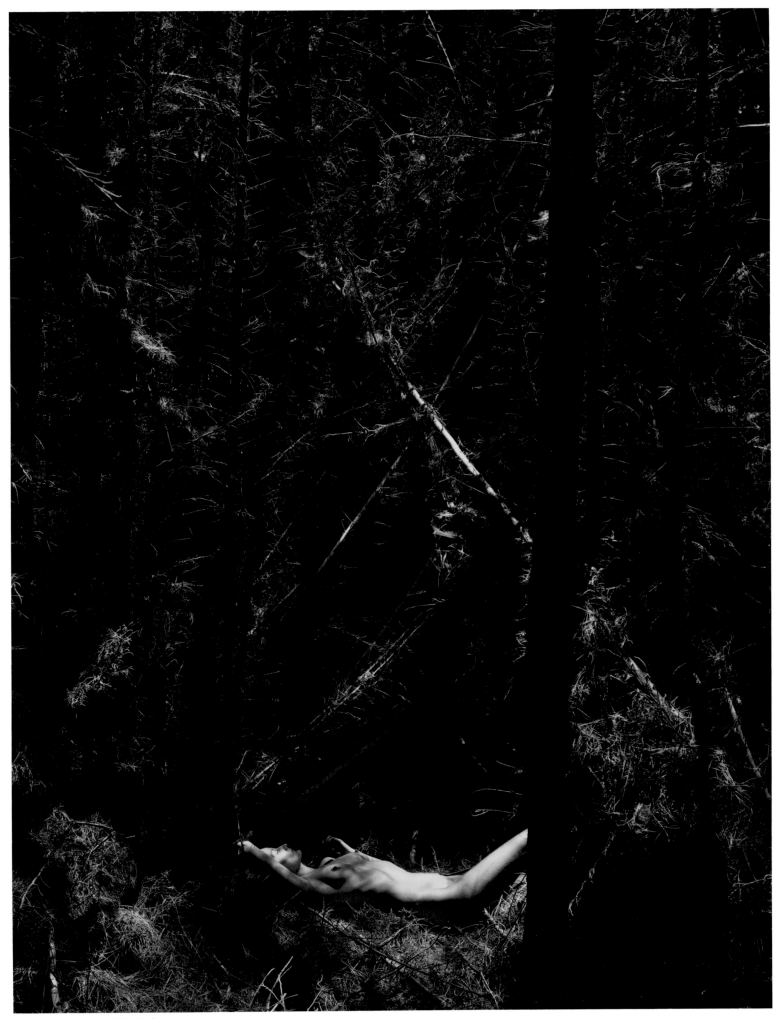

NUDE IN DEAD FOREST, 1954

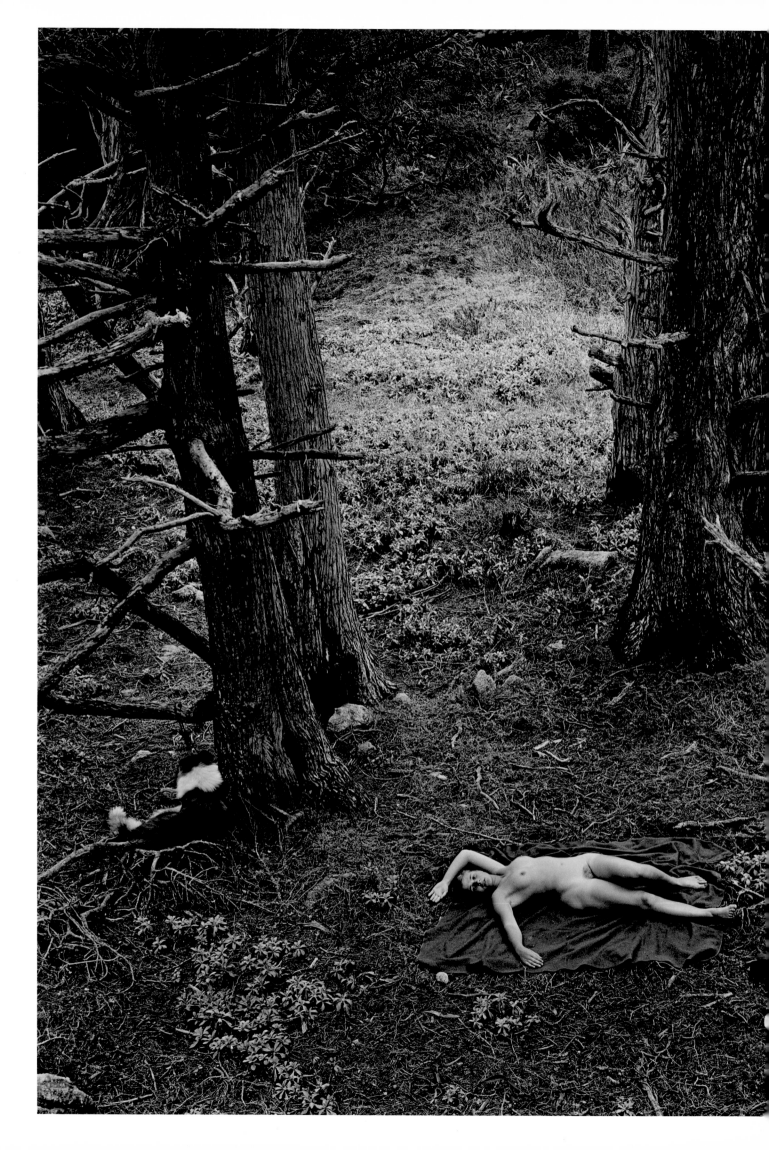

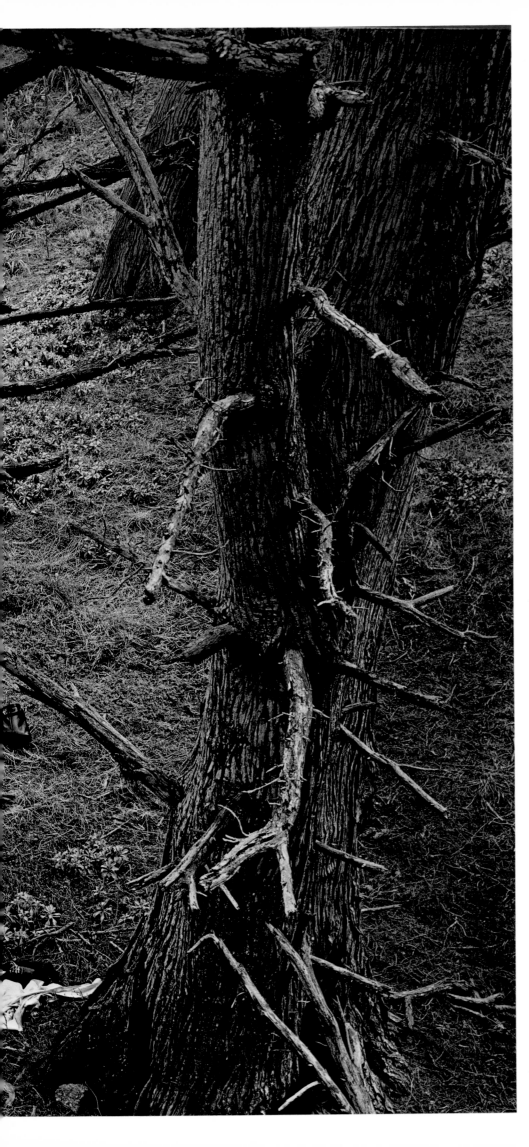

WOMAN AND DOG IN FOREST, 1953 25

One of the ways to emphasize both space
and time is to develop your sense of opposites.
If you skillfully photograph an older object
together with a younger one, the
qualities of each are enhanced by their
contrasting characters. As soon as I
became aware of this, I became aware of
the difference between seeing and perceiving.
Seeing is an automatic process, perceiving
is a mental, more complex process.
Out of perceiving begins growth.

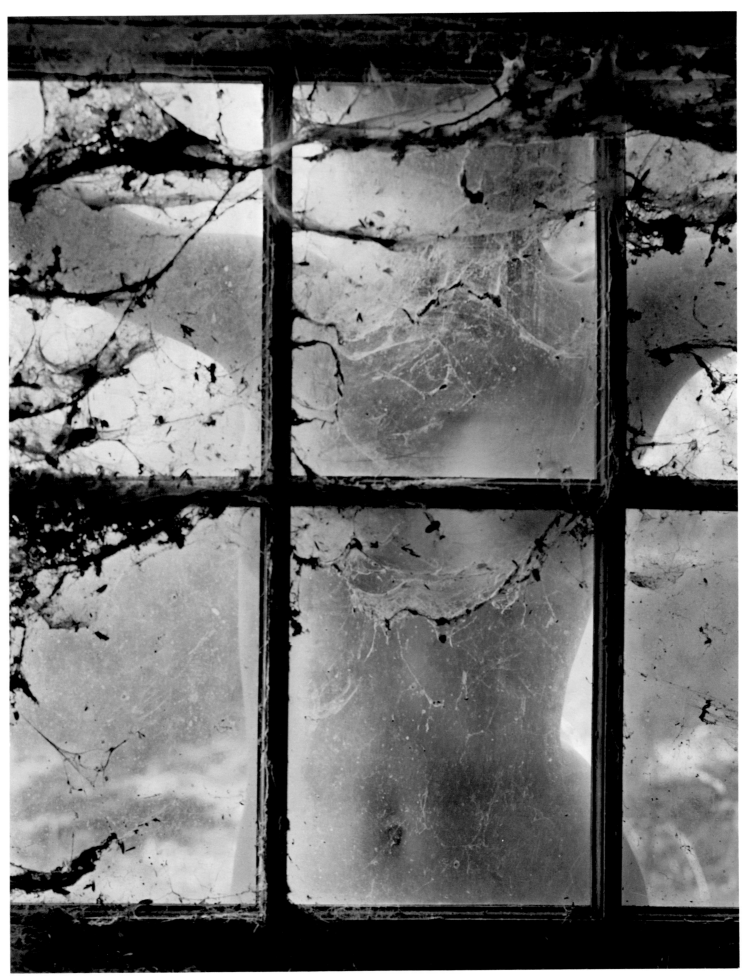

WOMAN BEHIND COBWEBBED WINDOW, 1955

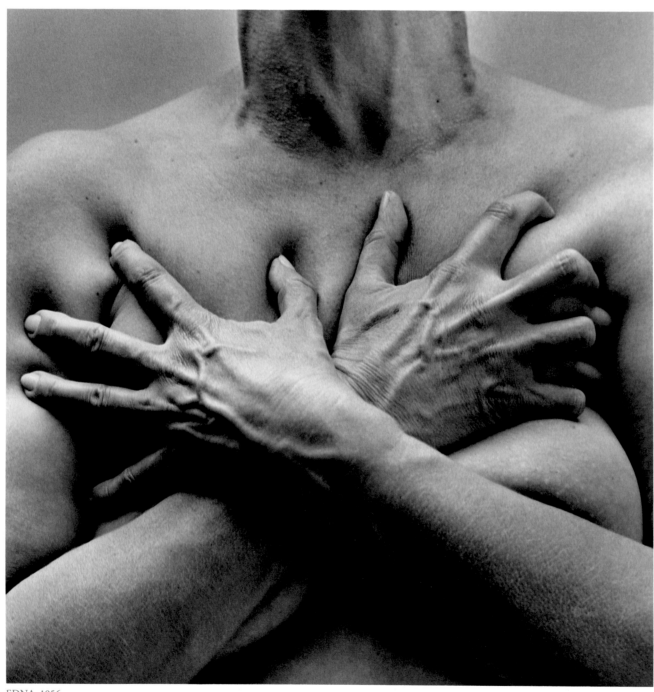

EDNA, 1956

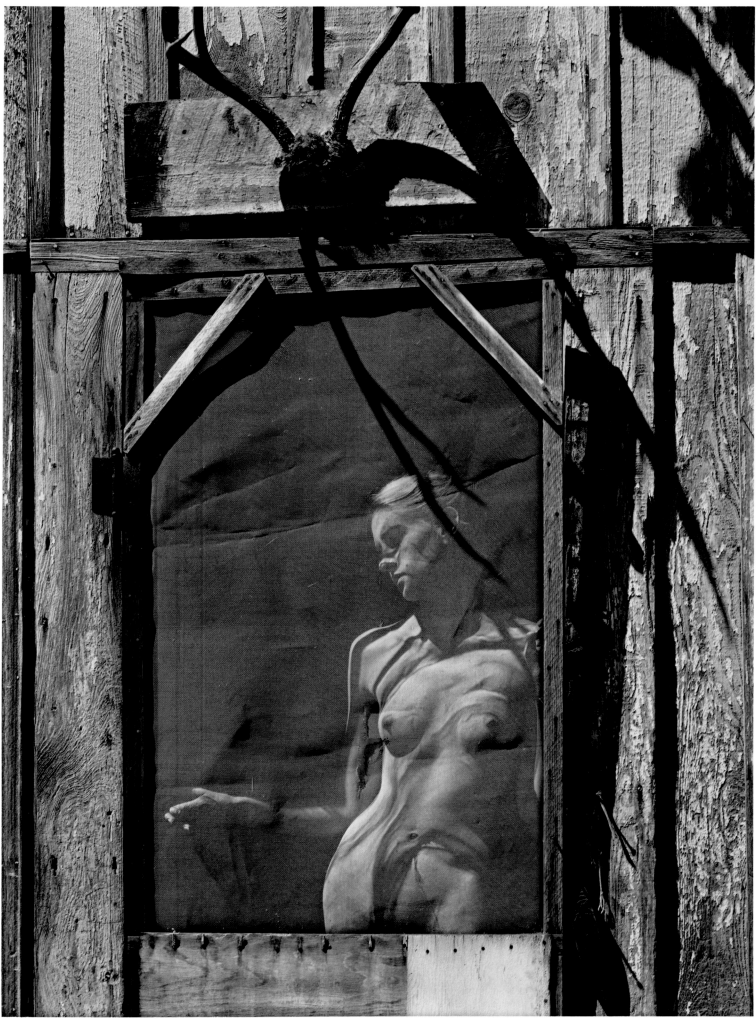

LUCIA, 1956

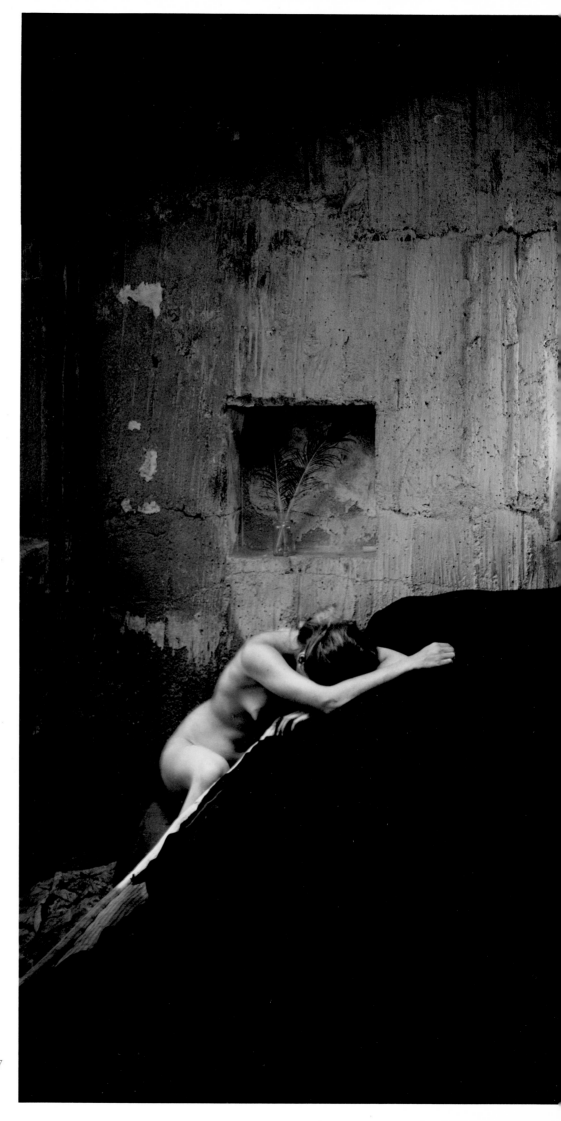

NAVIGATION WITHOUT NUMBERS, 1957

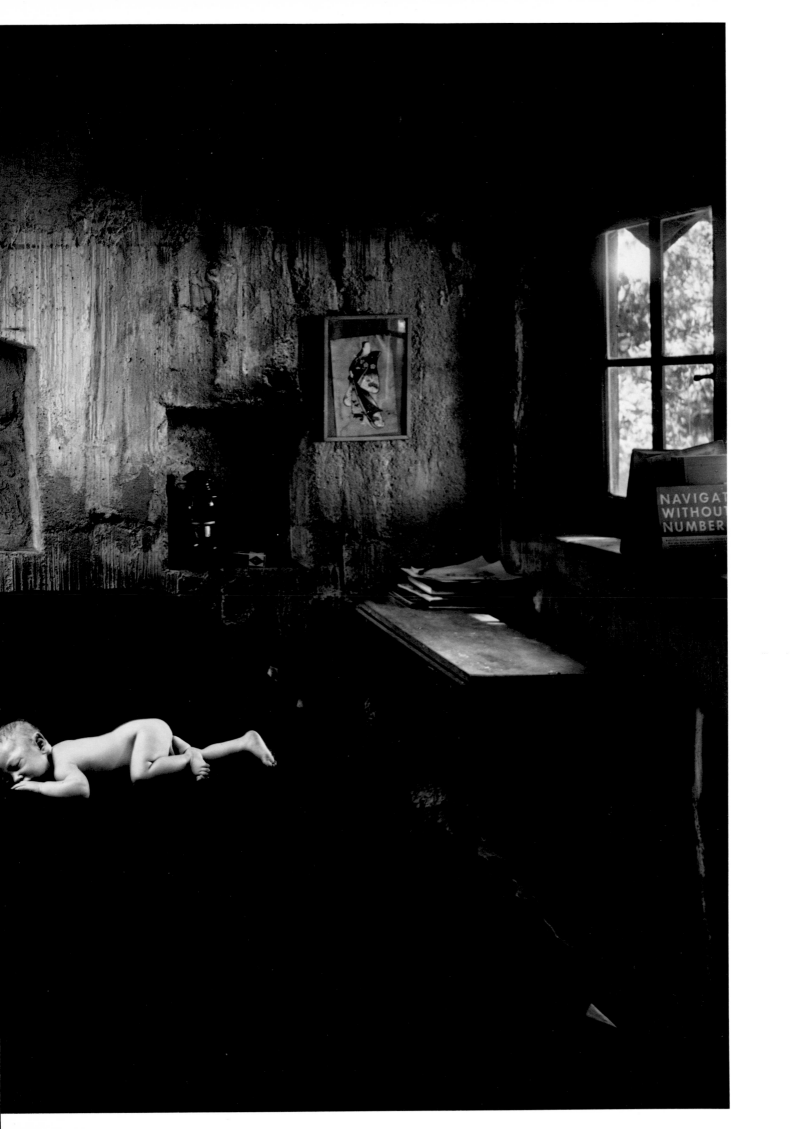

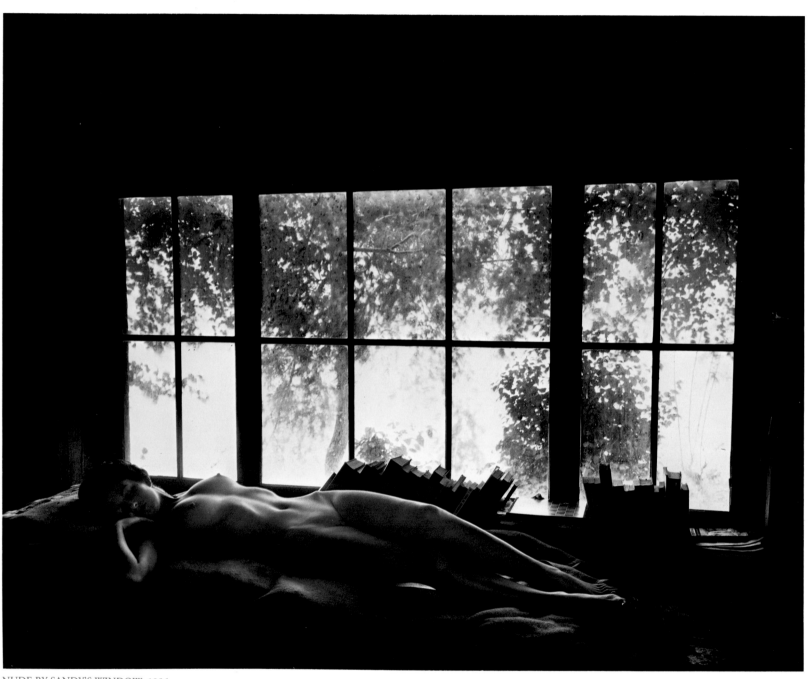

NUDE BY SANDY'S WINDOW, 1956

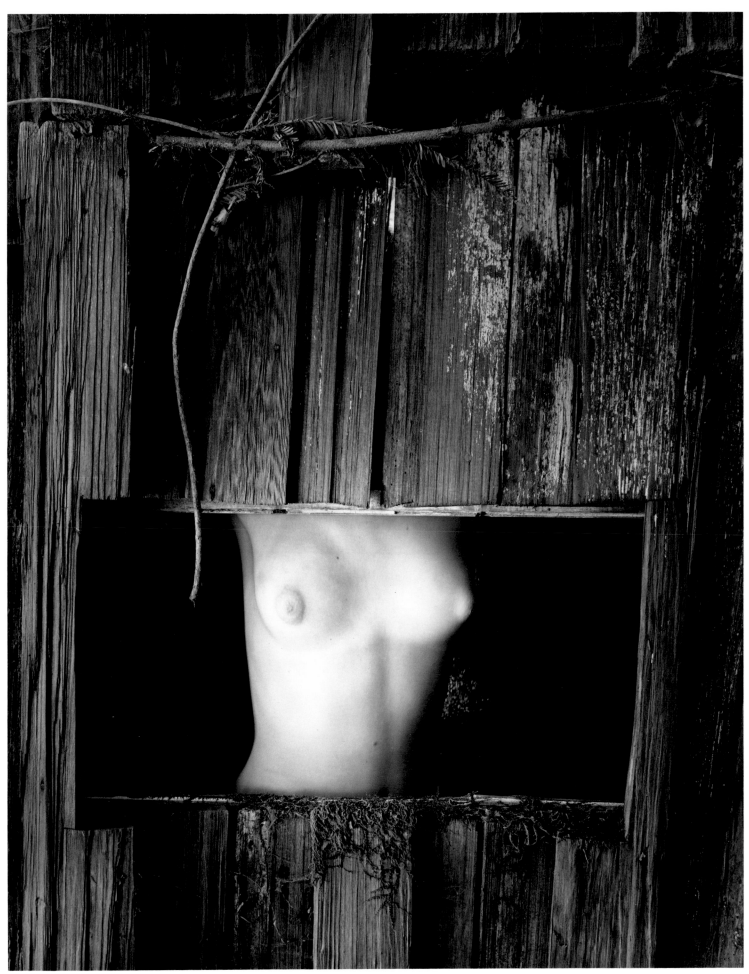

TORSO IN WINDOW, 1954

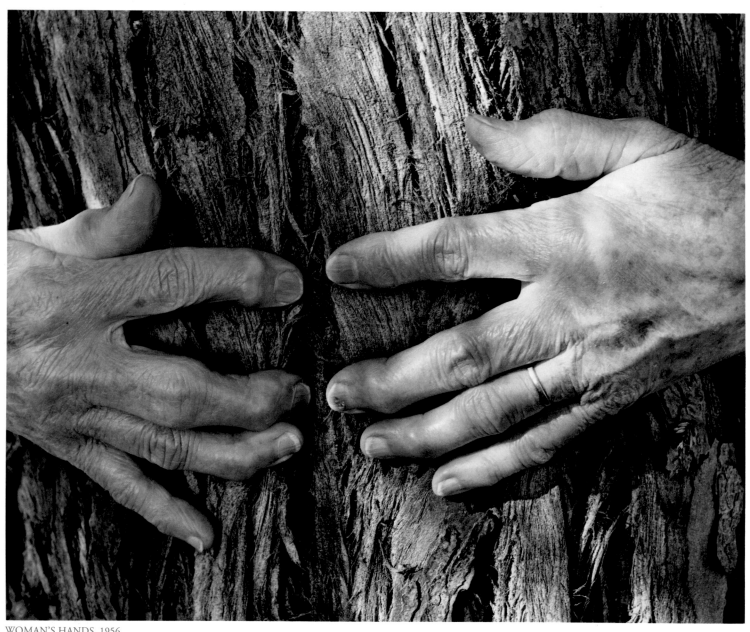

WOMAN'S HANDS, 1956

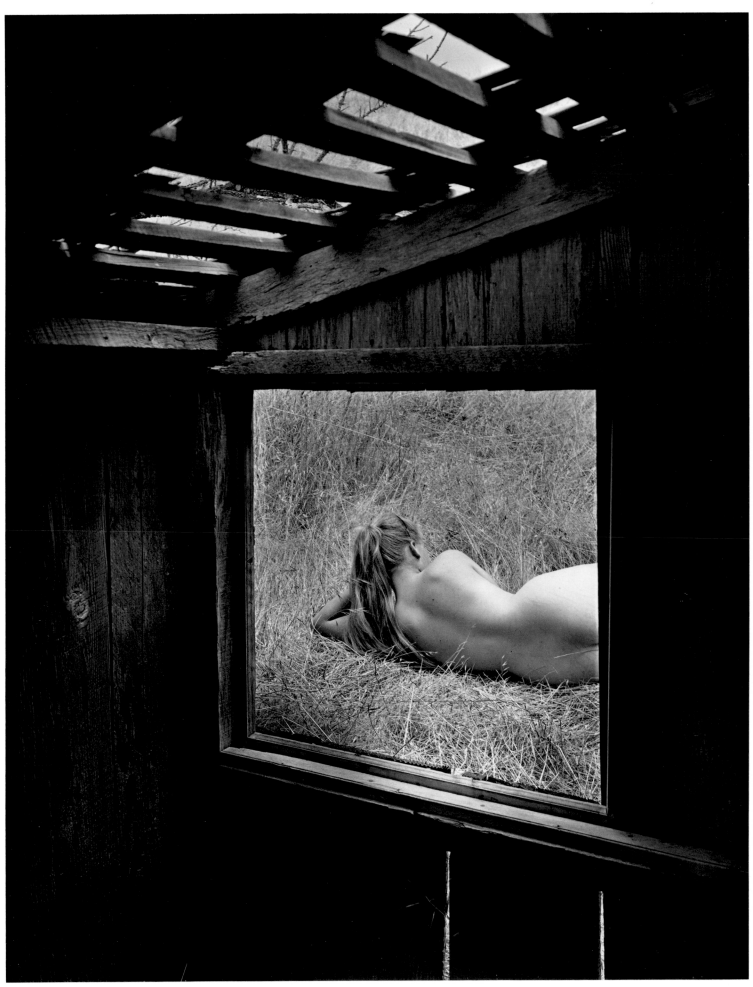

BARBARA THROUGH WINDOW, 1956

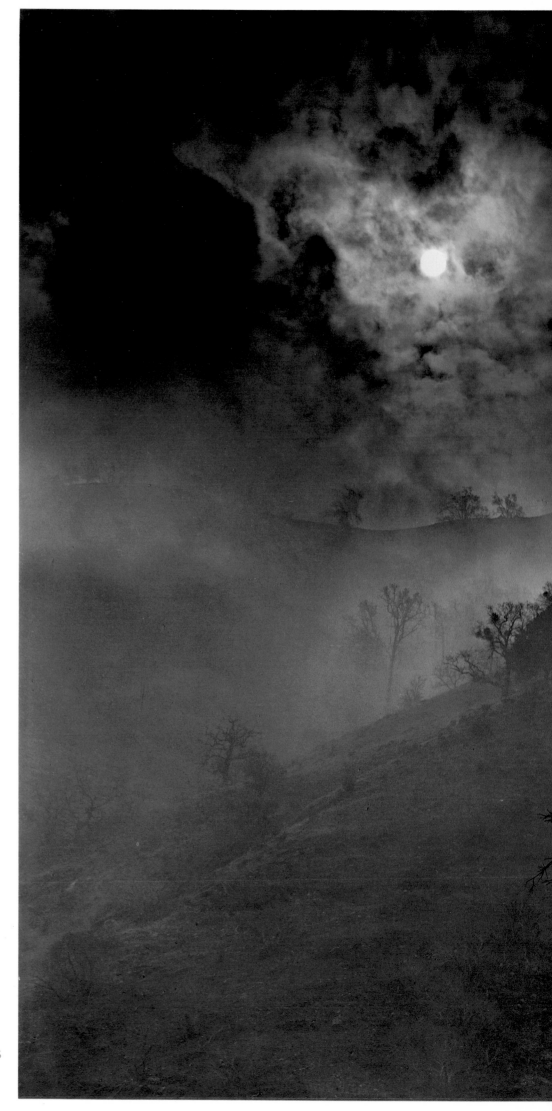

36 STARK TREE, 1956

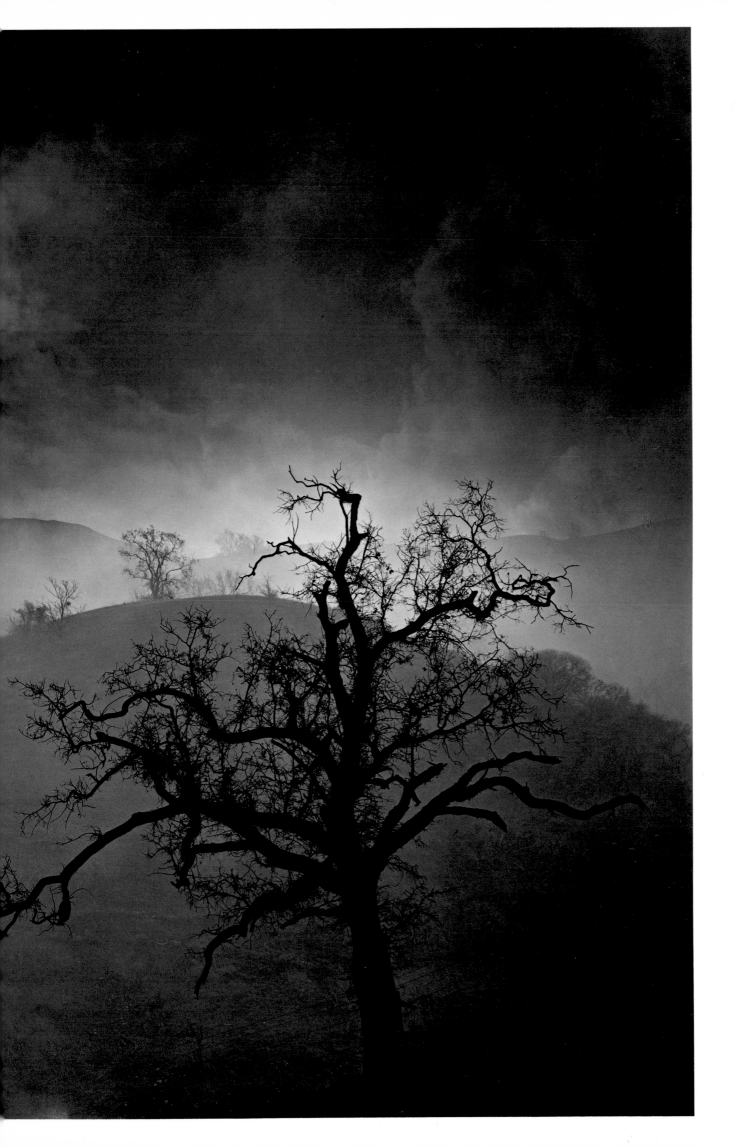

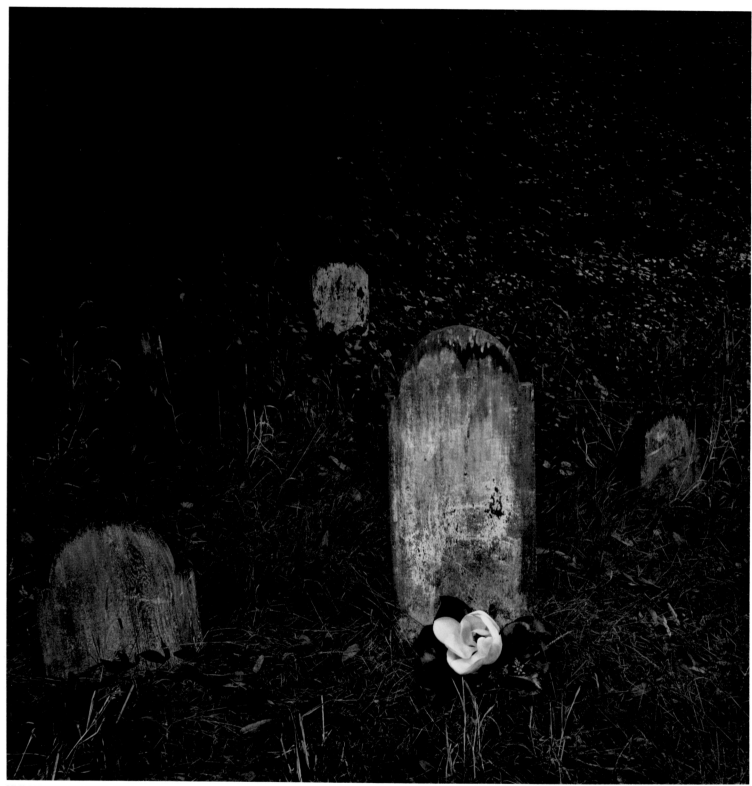

UNMARKED GRAVES, 1969

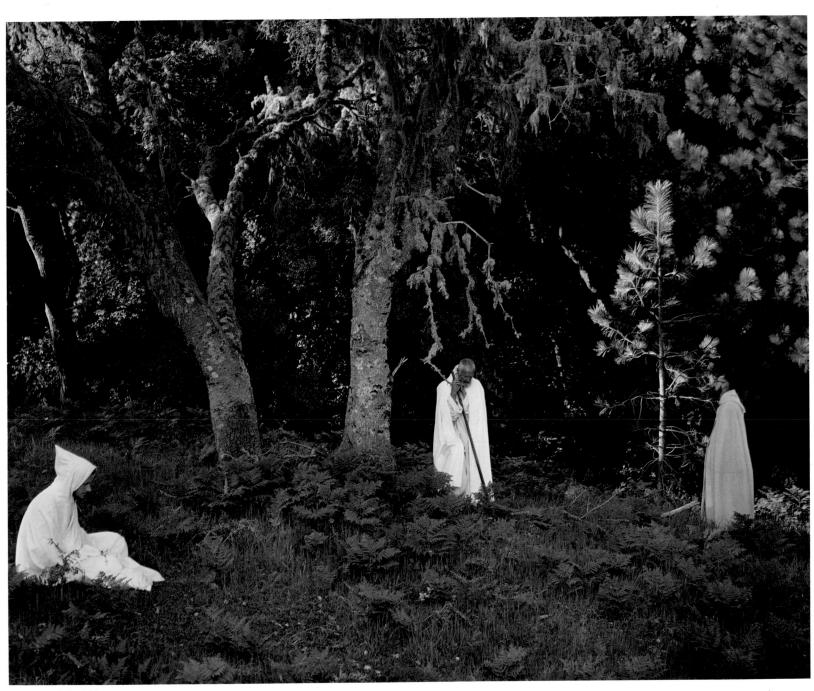

THE MONKS, 1959

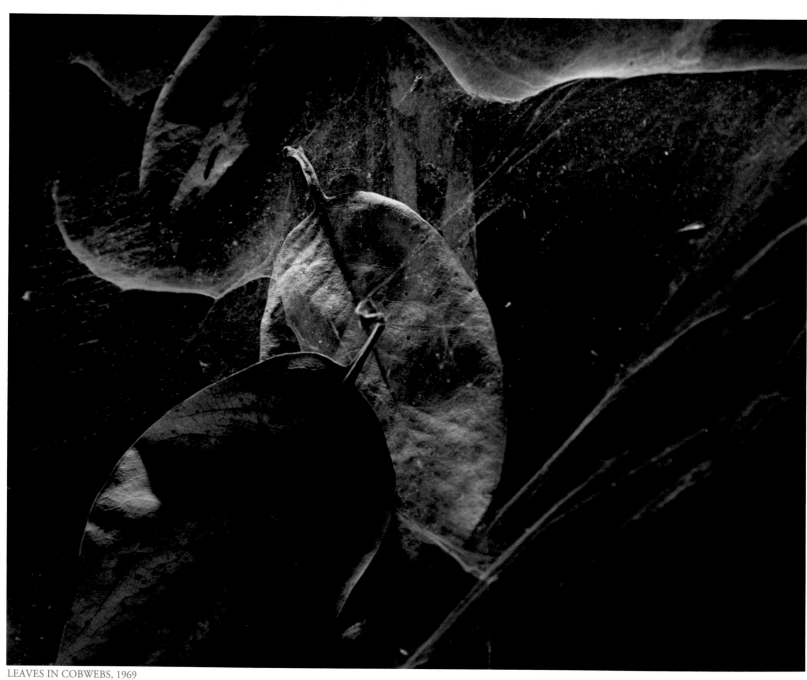

LEAVES IN COBWEBS, 1969

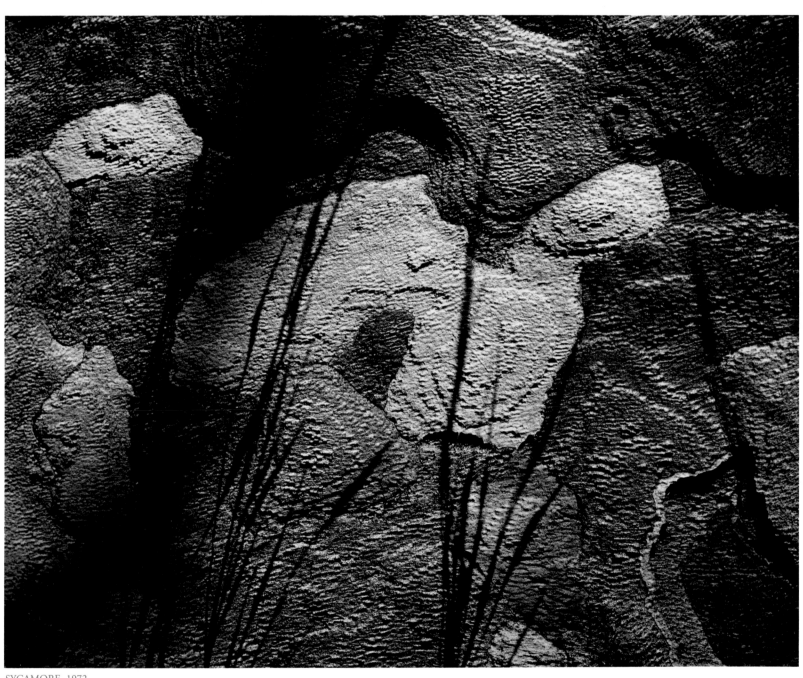

SYCAMORE, 1972

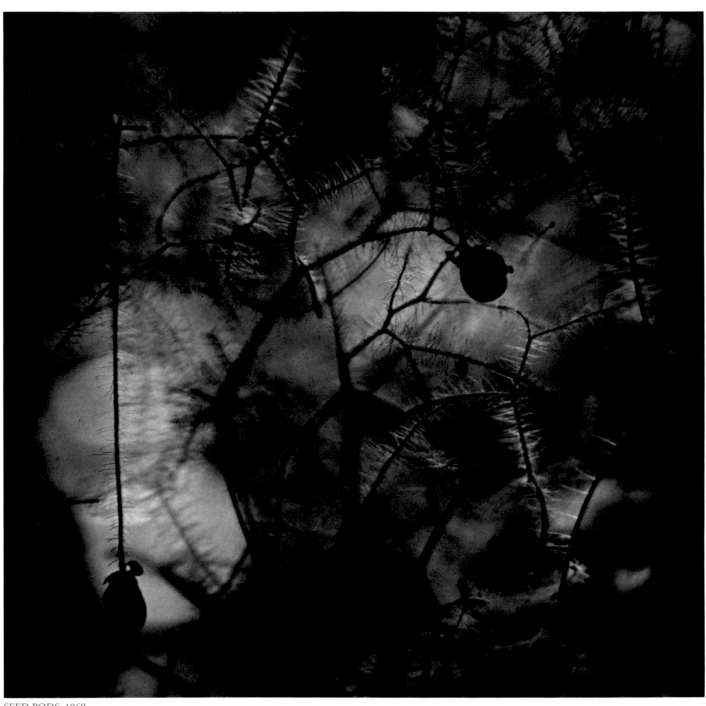

SEED PODS, 1969

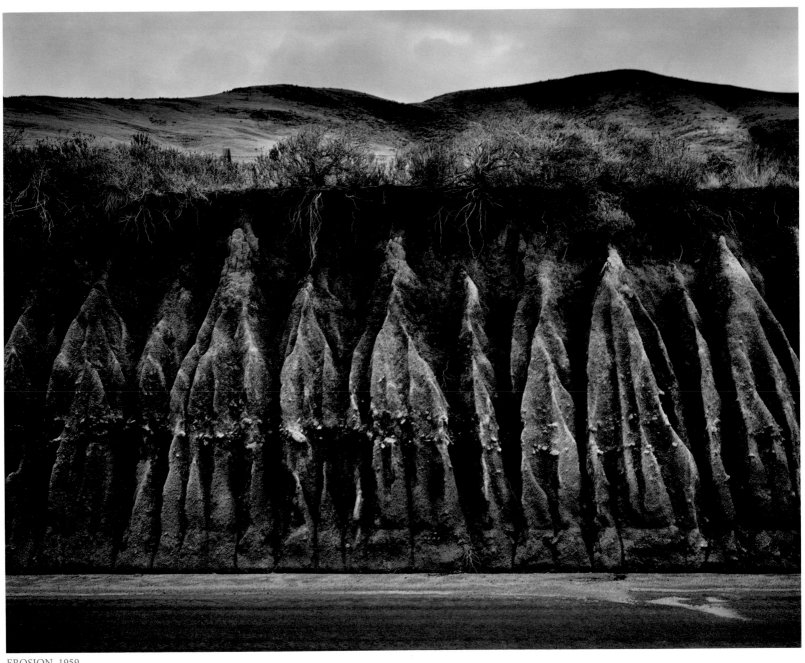

EROSION, 1959

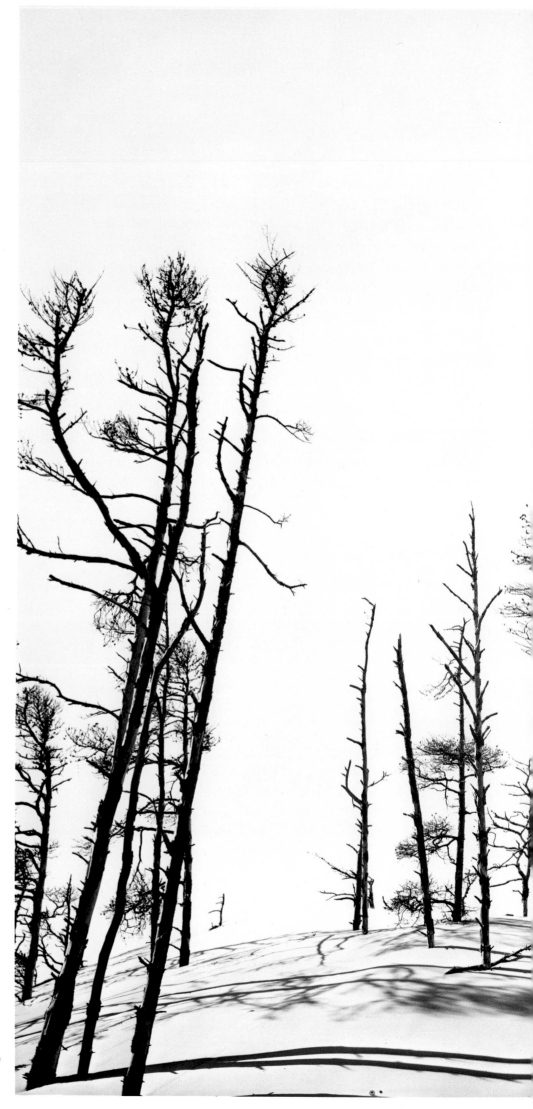

44 FLORENCE, TREES AND SAND DUNES, 1959

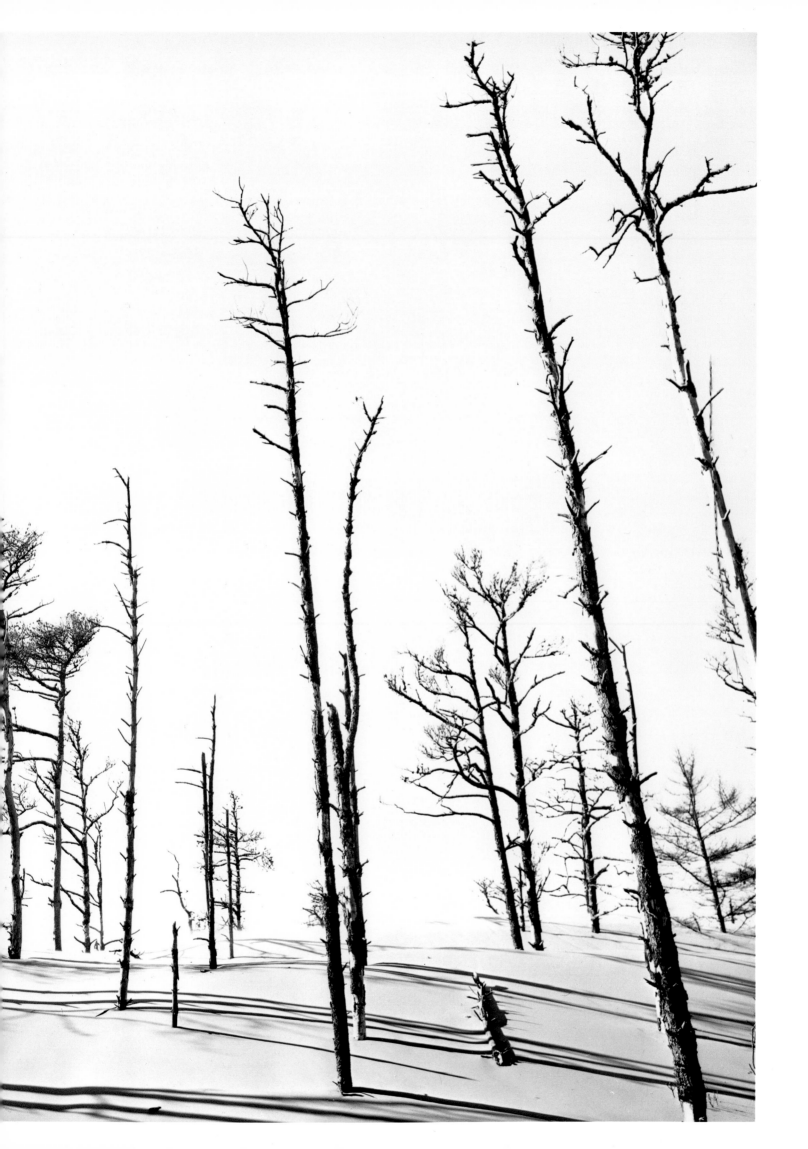

*Through applying the concept of space-time
to photography, I can create powerful symbols of my
experiences. I measure my growth as a
photographer in terms of the degrees to which I am
aware of and have the skills to symbolize visually
the four-dimensional structure of the universe.*

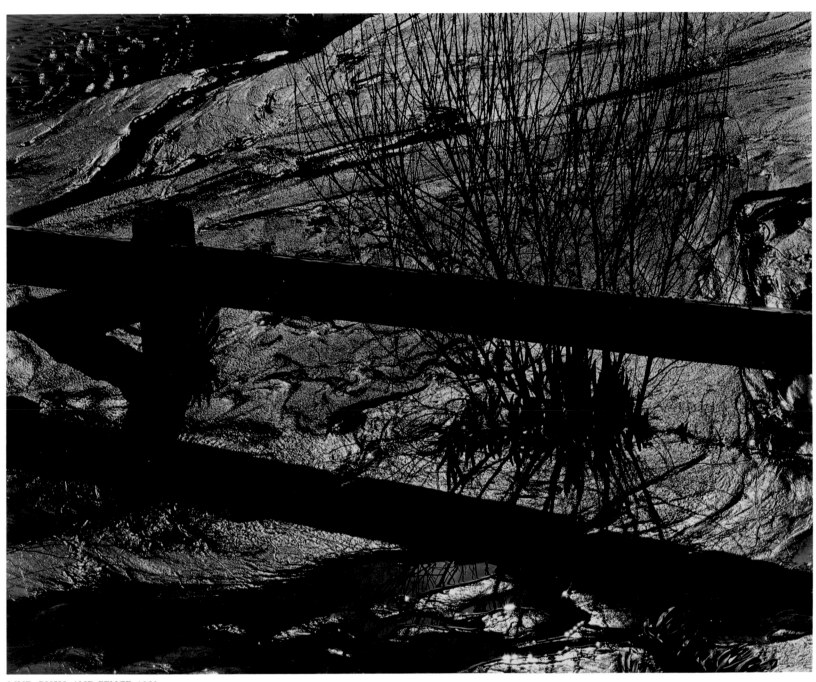

MUD, BUSH, AND FENCE, 1953

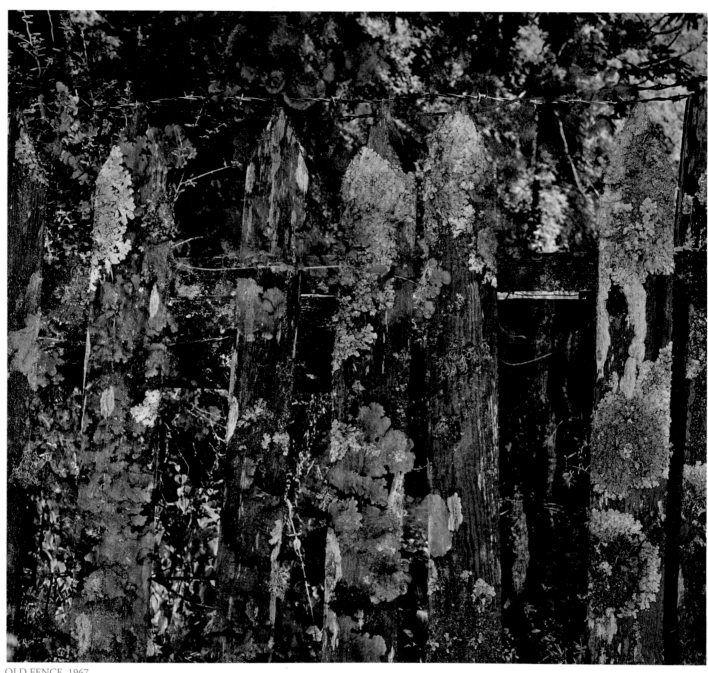

OLD FENCE, 1967

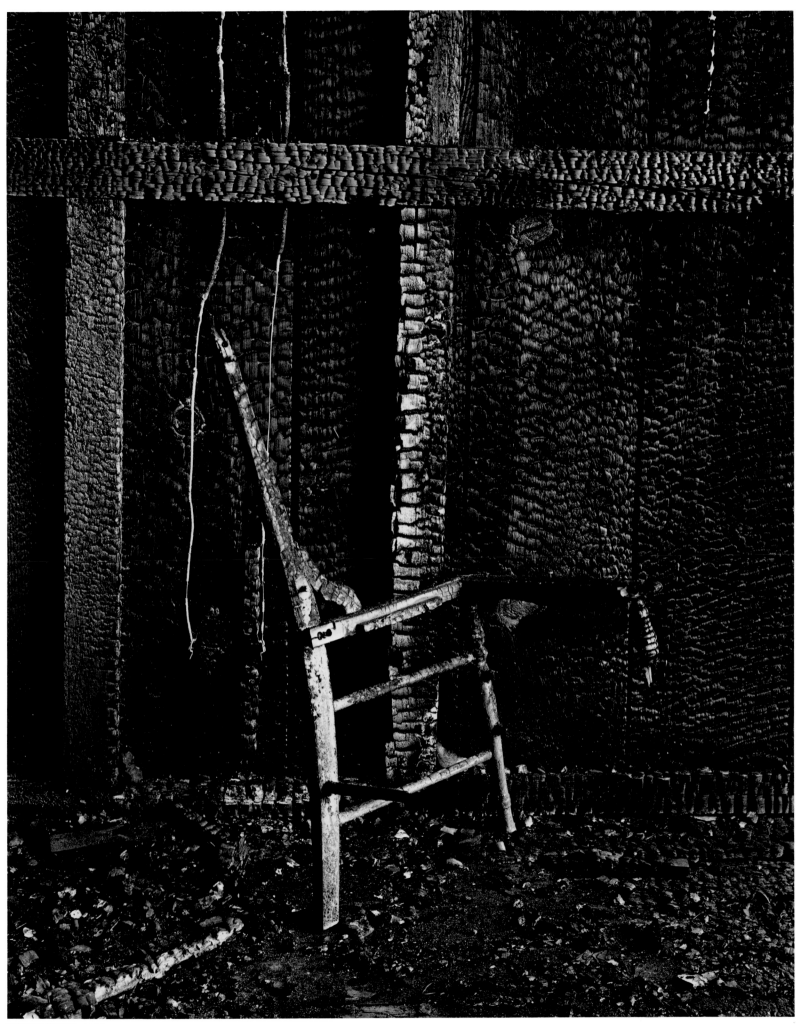

BURNT CHAIR, 1954

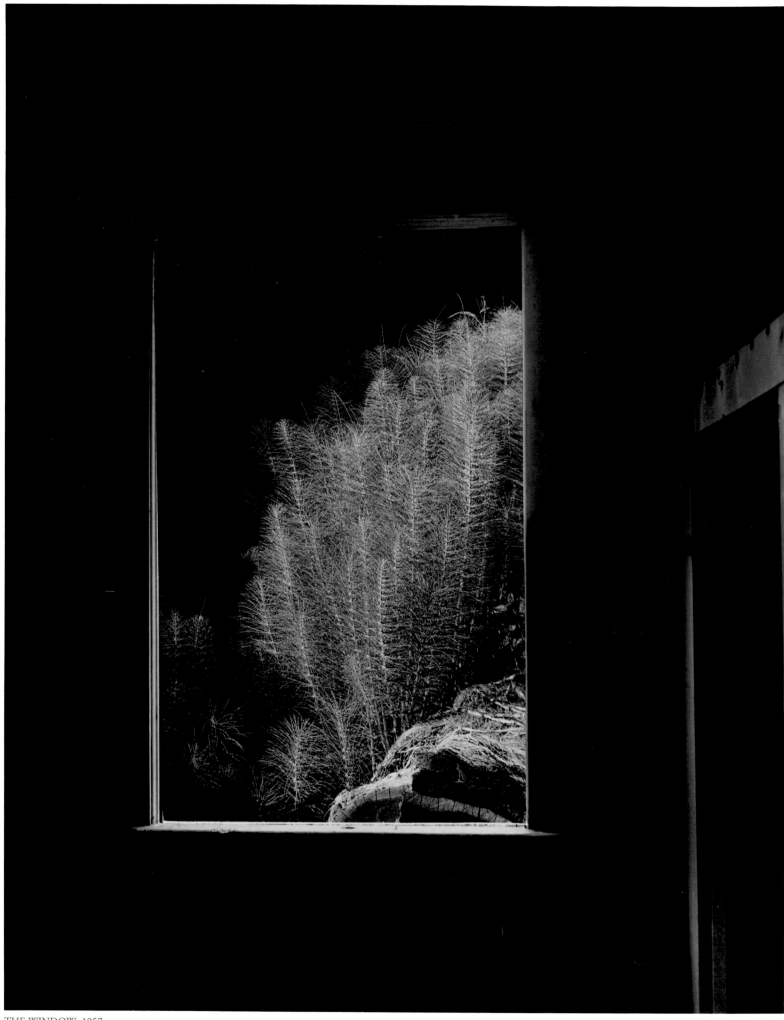

THE WINDOW, 1957

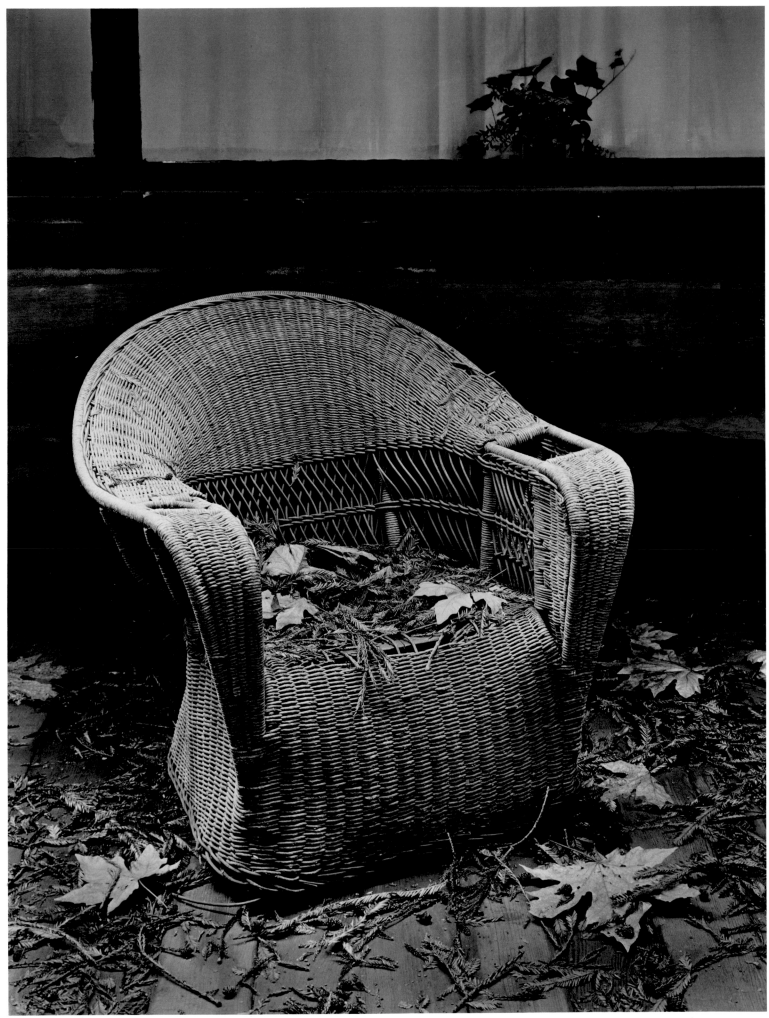

OLD CHAIR, 1951

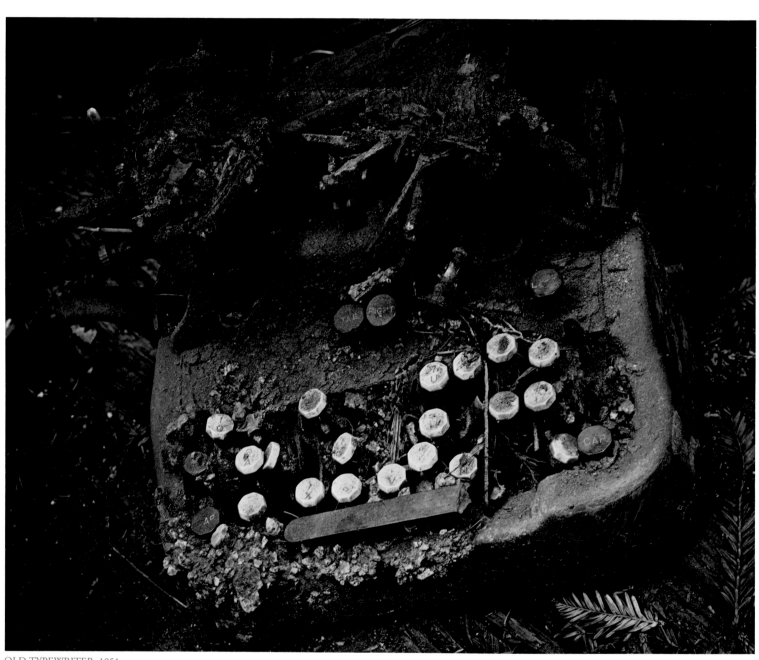

OLD TYPEWRITER, 1951

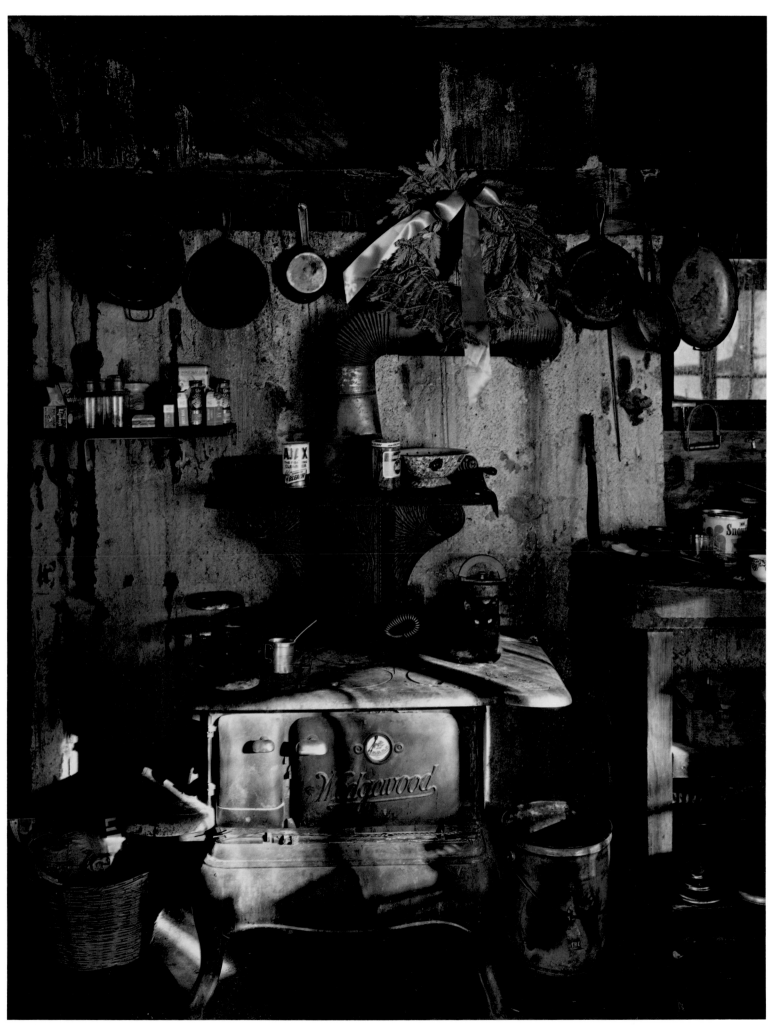

CHRISTMAS AT SANDY'S, 1956

CHESS GAME, 1955

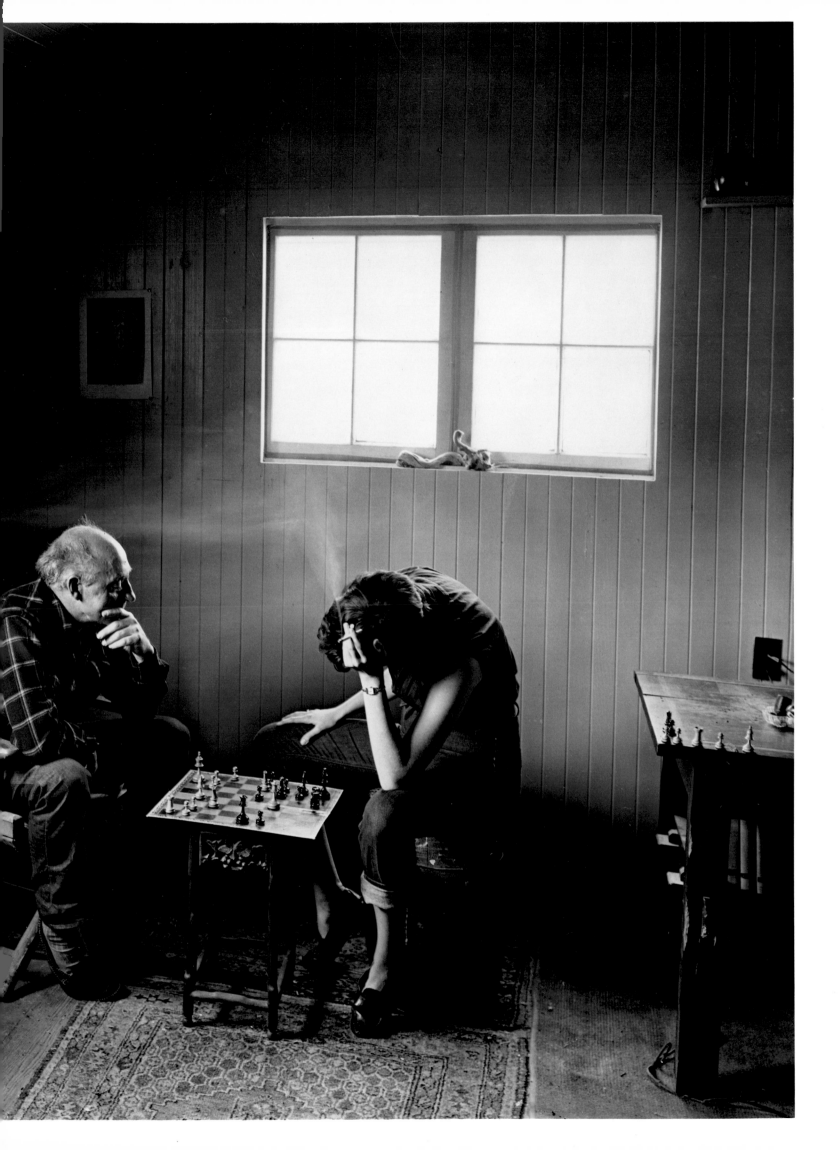

*My pictures are never pre-visualized or
planned. I feel strongly that pictures must
come from contact with things at the time and
place of taking. At such times, I rely on
intuitive, perceptual responses to guide me,
using reason only after the final print
is made to accept or reject the results of my
work. Although both reason and
intuition are equally important tools that
help me grow visually, the creative act
itself comes from an intense, direct,
one-to-one relationship between
myself and whatever I photograph.*

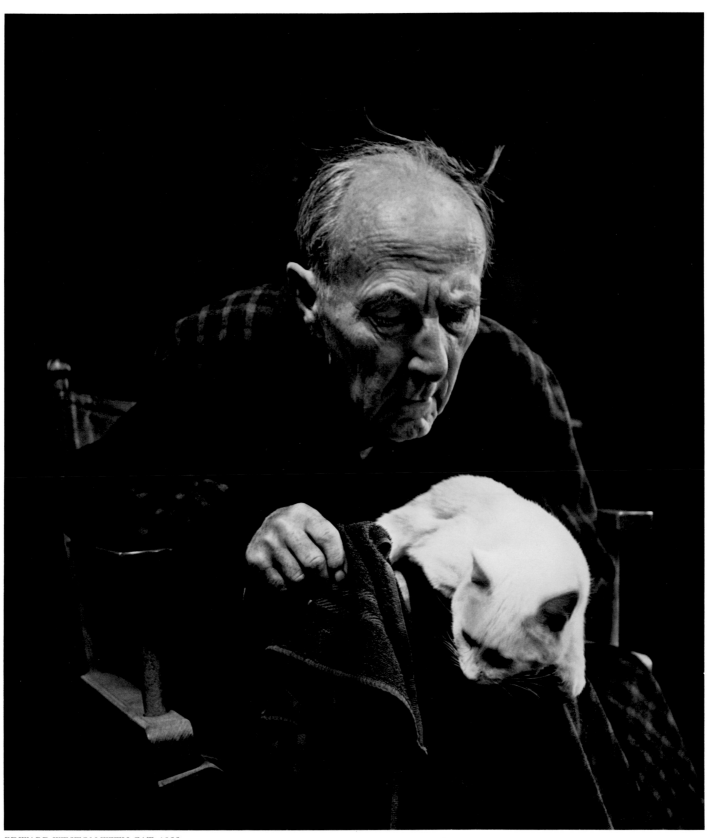

EDWARD WESTON WITH CAT, 1955

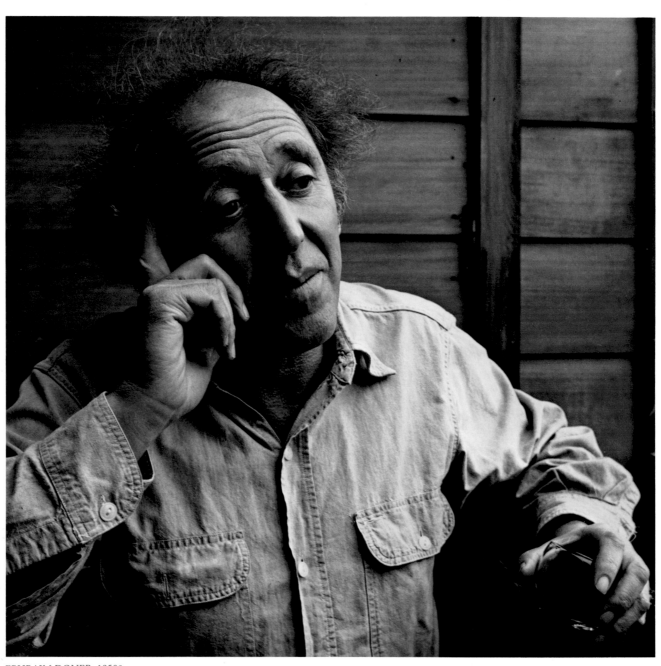

EPHRAIM DONER, 1950S

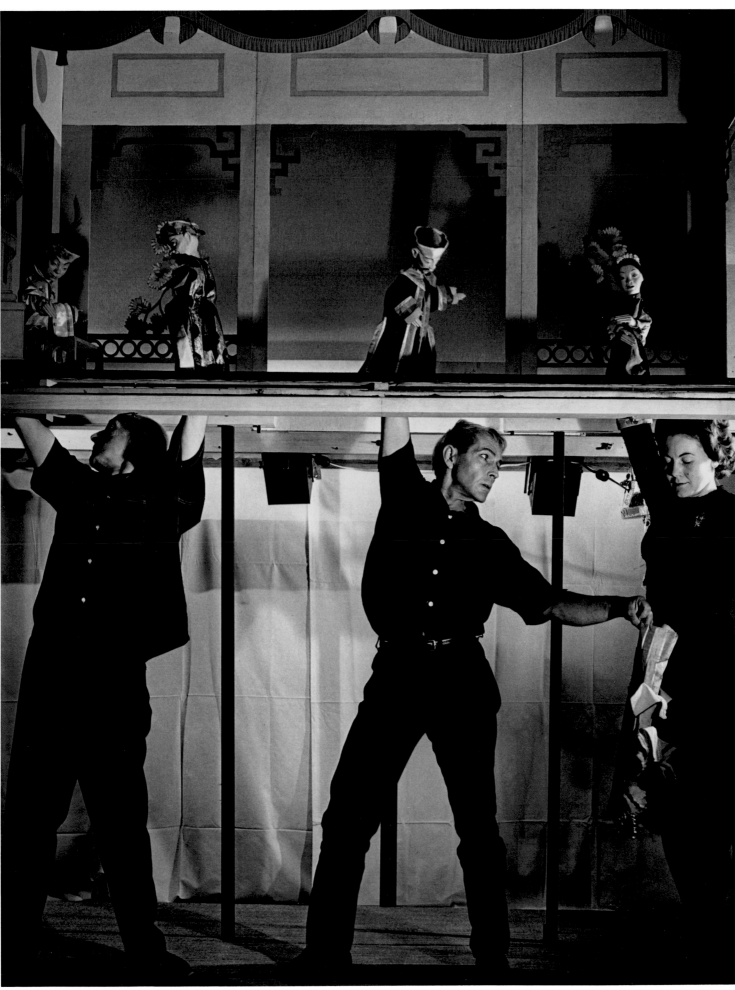

PUPPETEERS, 1950s

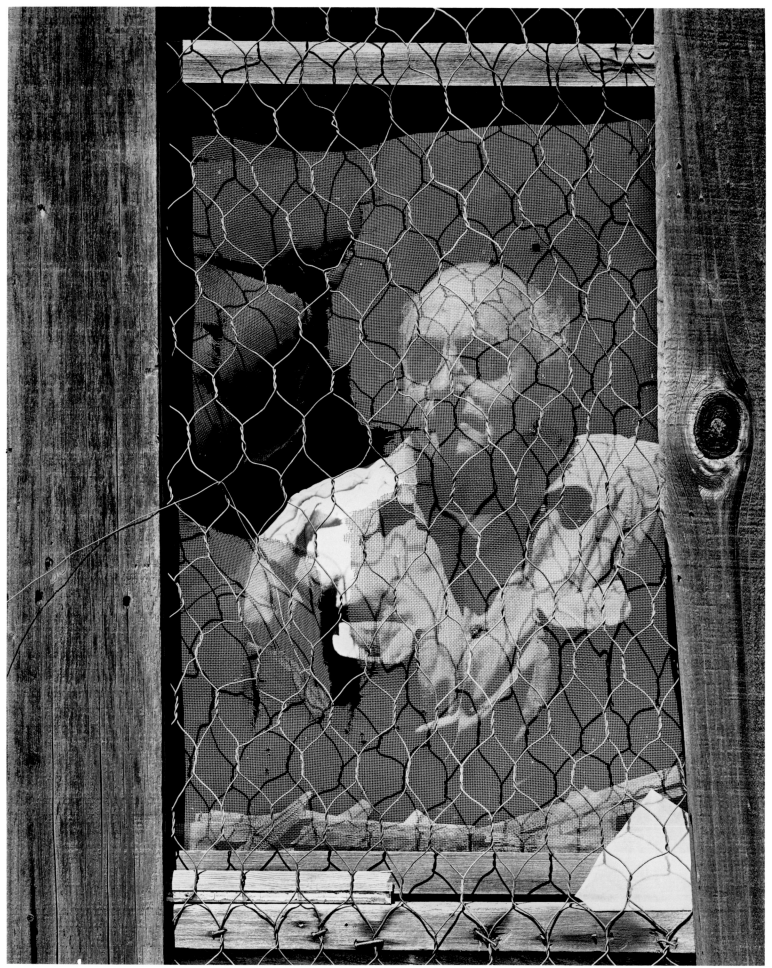

ERIC, 1955

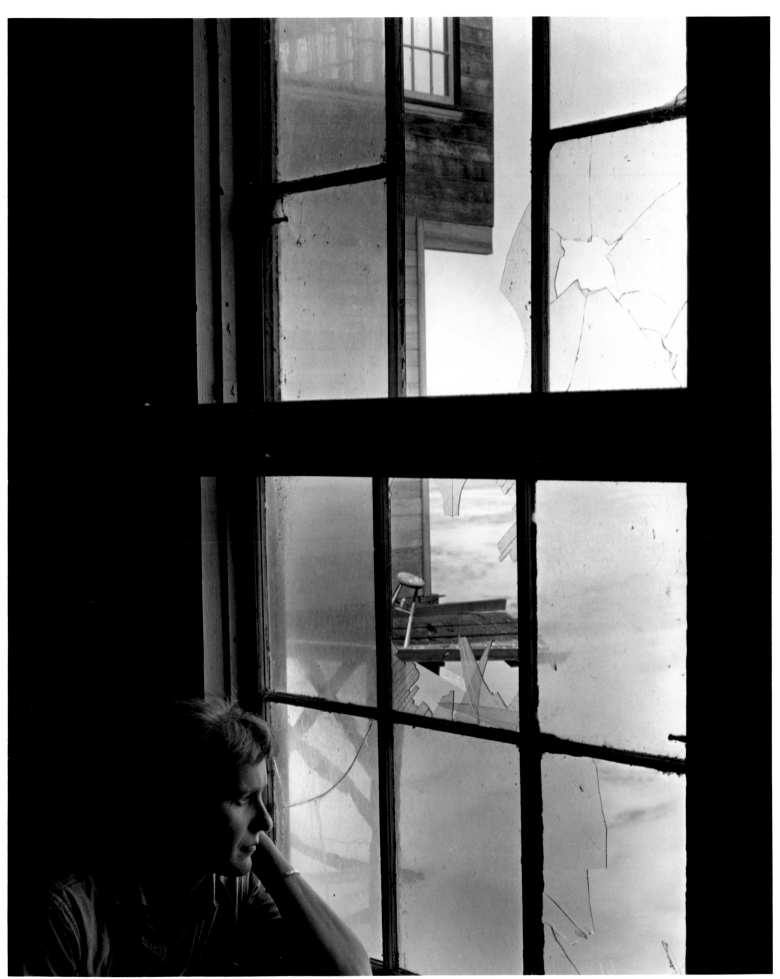

EDNA, CANNERY ROW, 1950S

*All we really can do as
photographers or painters or writers
or theoretical physicists is to
create symbols that enlarge and
expand the self. The symbols we
choose are not important because we
choose them but because the
things symbolized are important.*

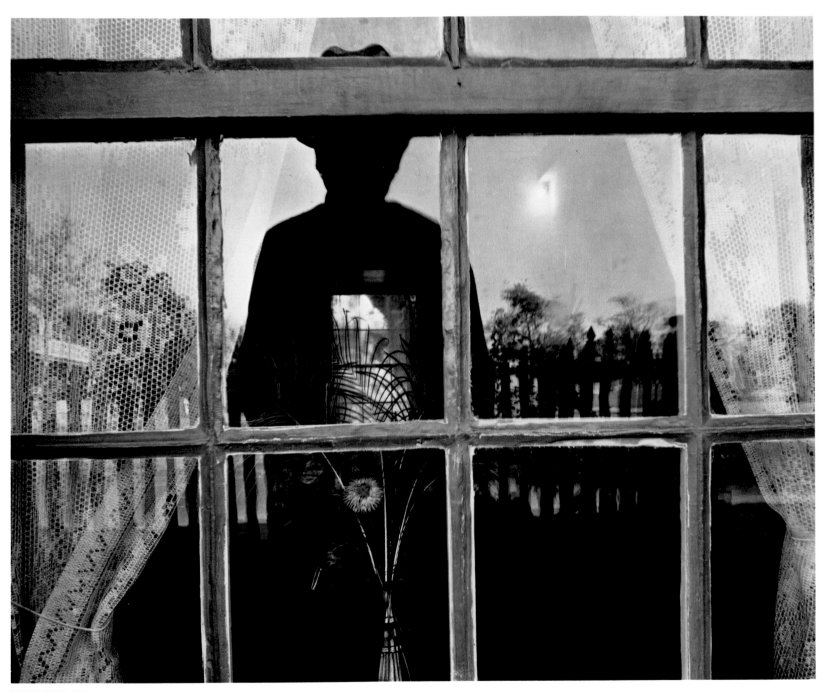

SELF-PORTRAIT, 1971

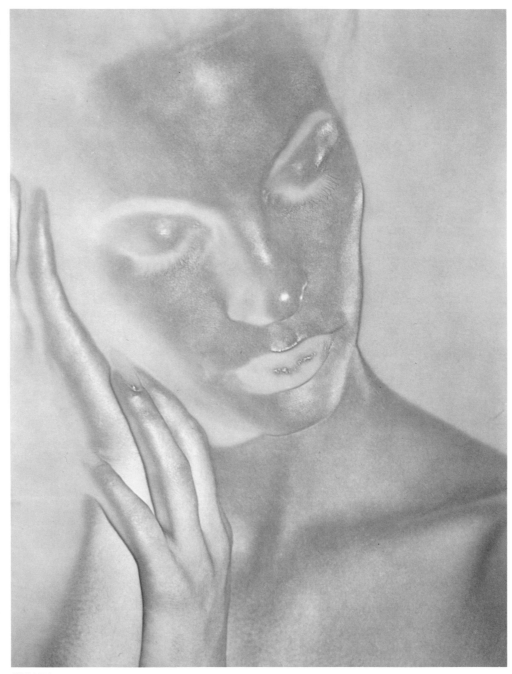

SOLARIZED HEAD, 1940

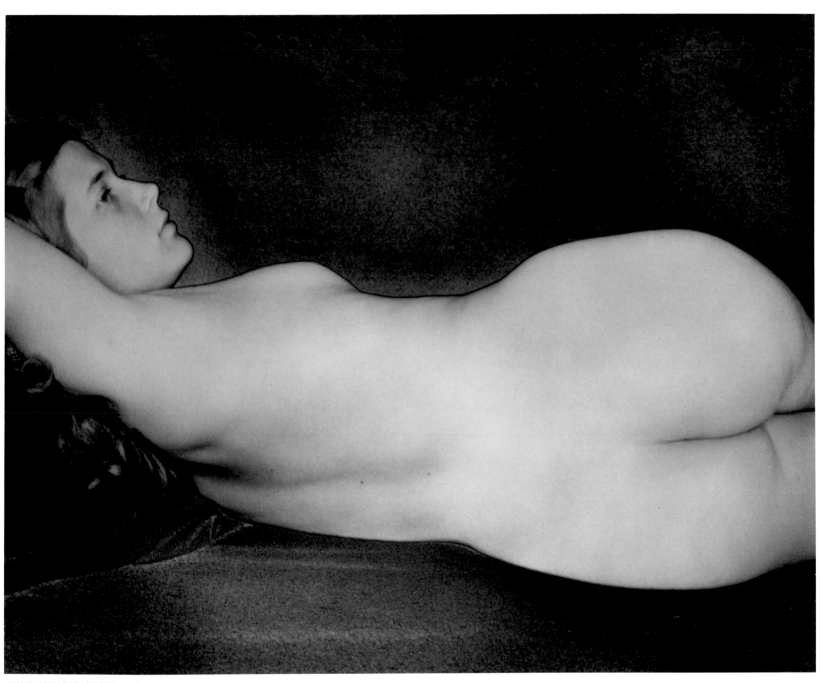

NUDE SOLARIZATION, 1953

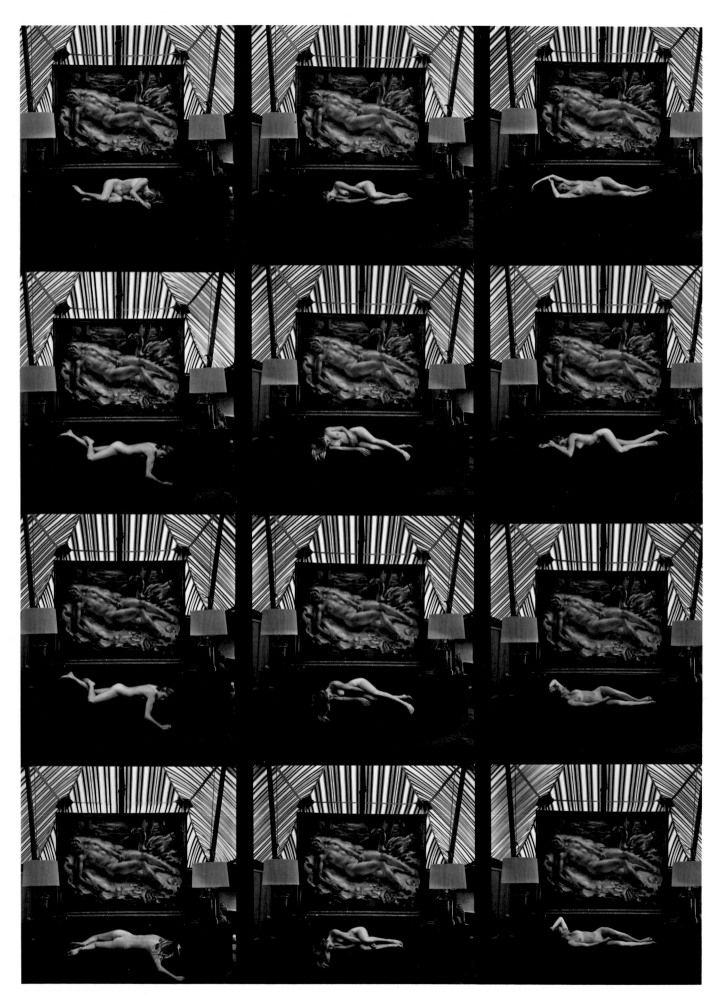

SLEEPING GIRL, 1968

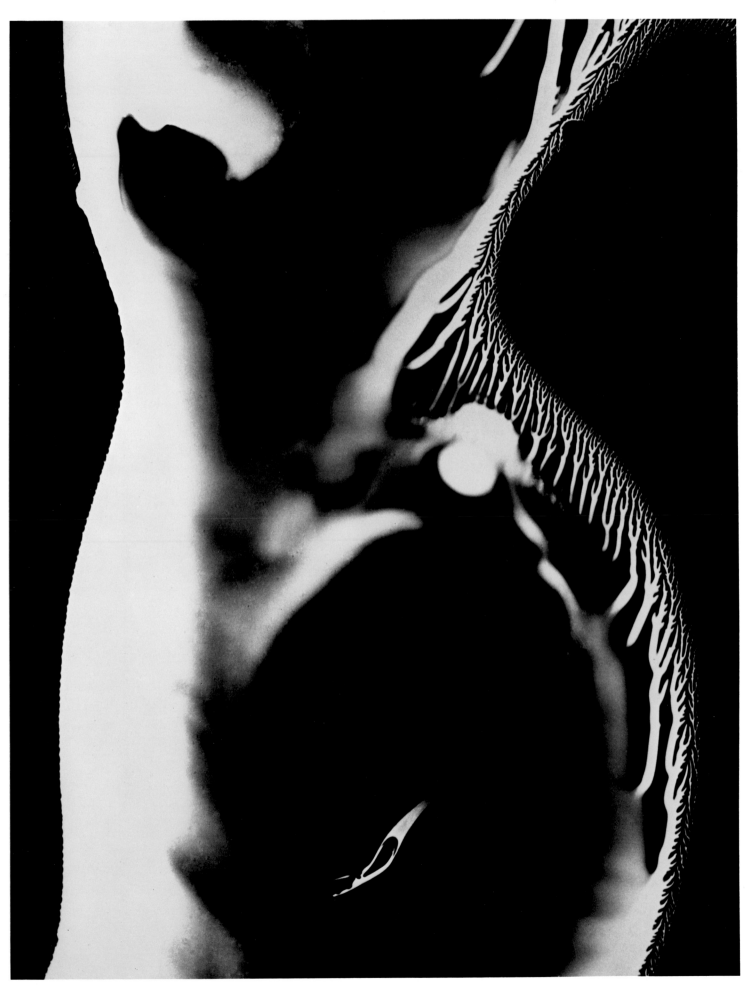

NUDE PHOTOGRAM, 1970

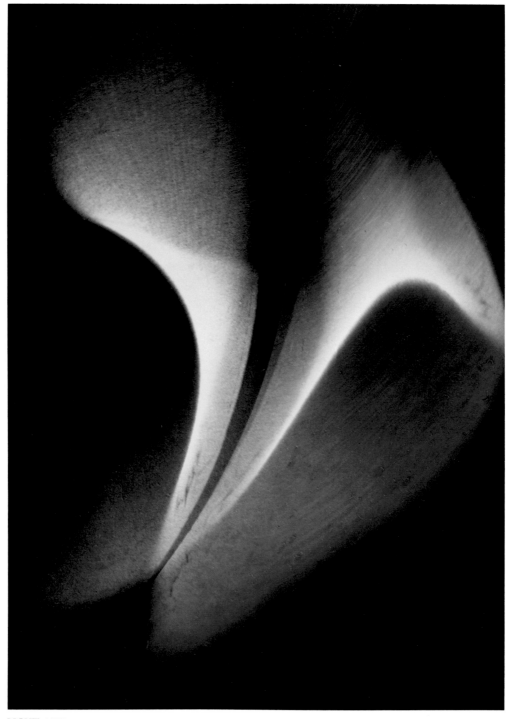

LIGHT, 1939

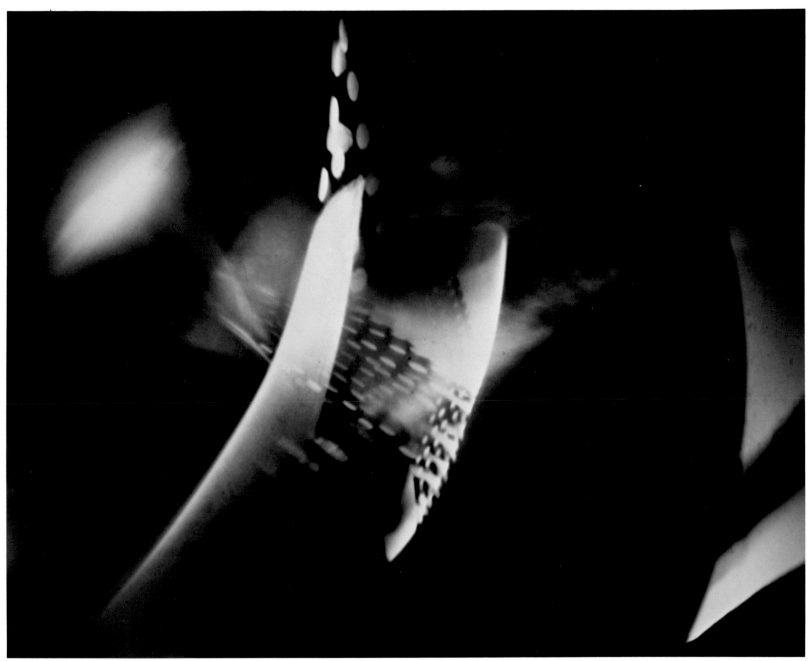

LIGHT #1, 1952

*In my search to find an opposite to
reality, I discovered that if reality is the
knowable and the potentially knowable, the
opposite consists of things that the mind
can't comprehend. Among those things
are keys to the existence of everything.
The further we delve into what
we are and what things are, the more
mysterious we and they become.*

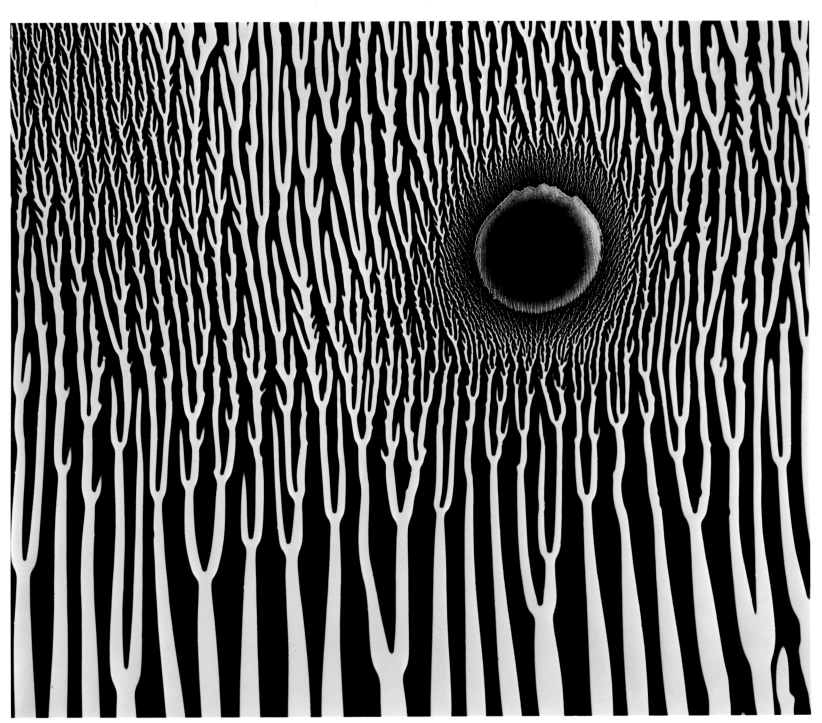

PHOTOGRAM, 1970

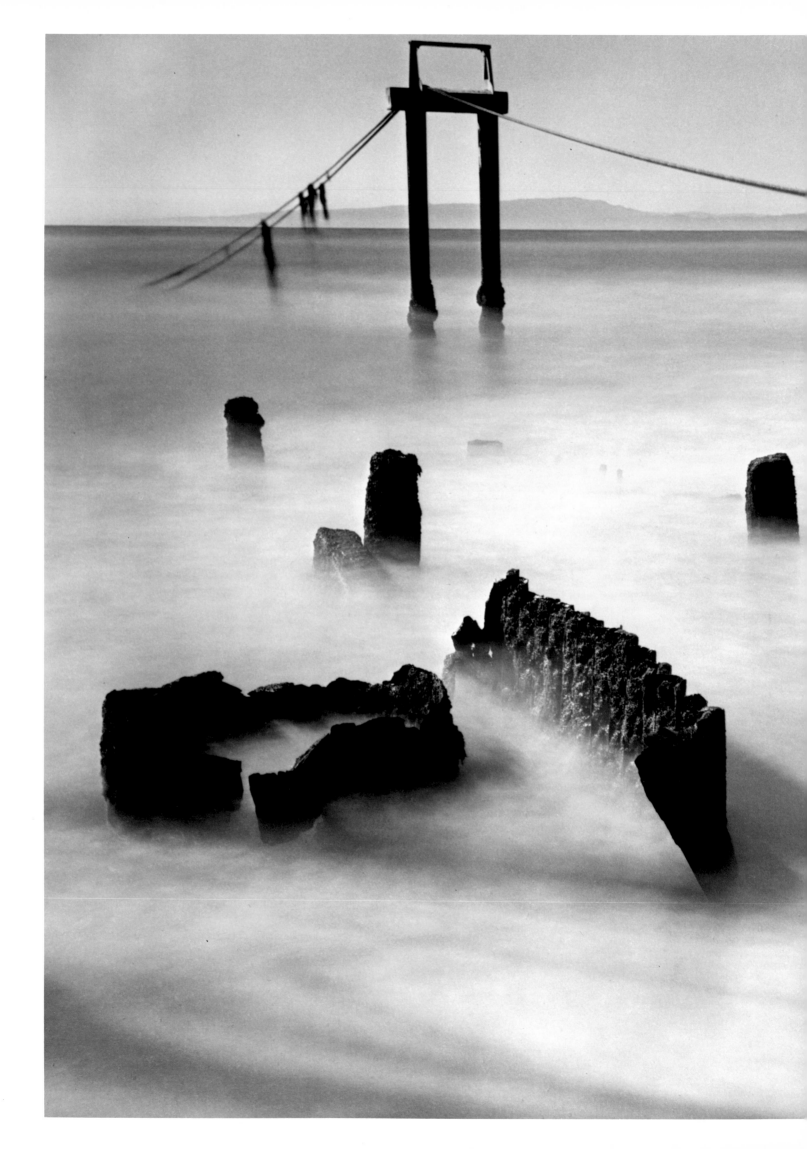

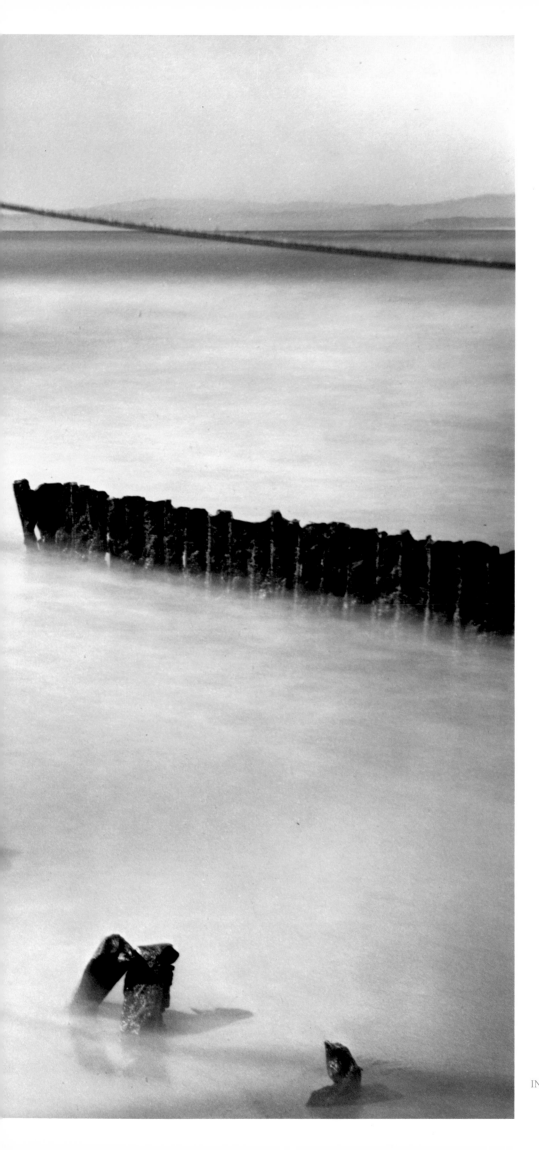

IN THE SURF, 1968　　　　73

*I feel the time of a thing just as
strongly as I see its form or color. Equally,
the spaces between the limbs of a tree are
as real as the limbs themselves. When I can
photograph spaces filled with smoke, fog,
or mist, the effect is one that greatly
adds to the visual and emotional impact
of the picture. The photographer
is slowly becoming aware of, and more
and more will extend, his search
for greater visual expression in a reality
that is not frozen in time or limited to
the surface appearance of objects.*

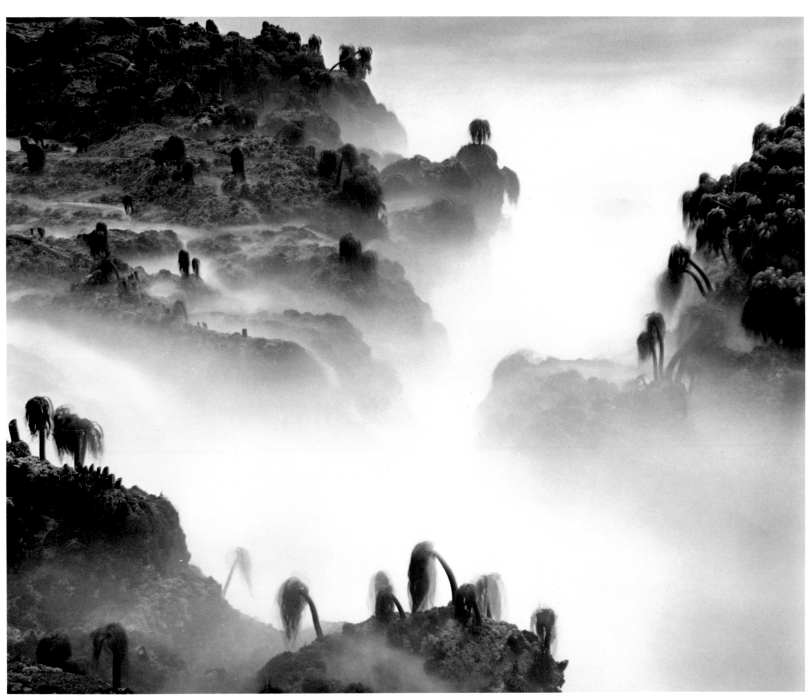

SEA PALMS, 1968

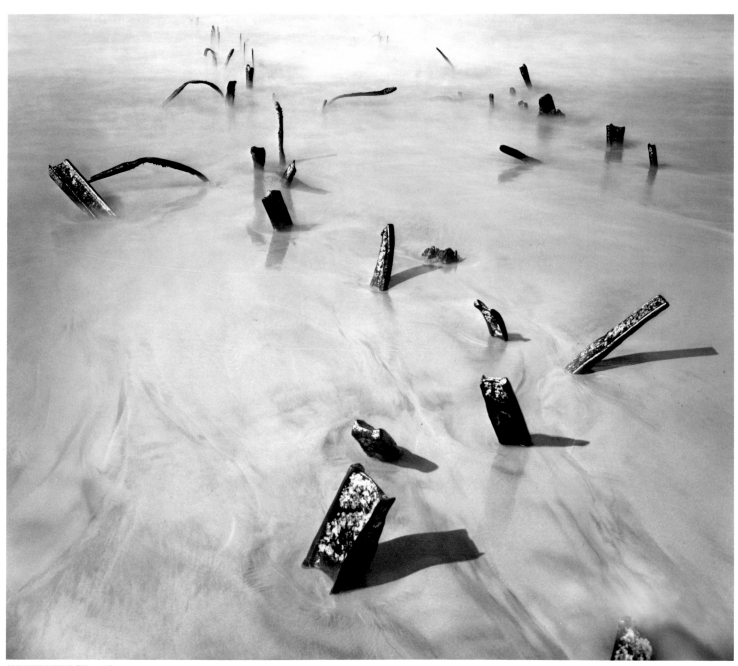

SUNKEN WRECK, 1968

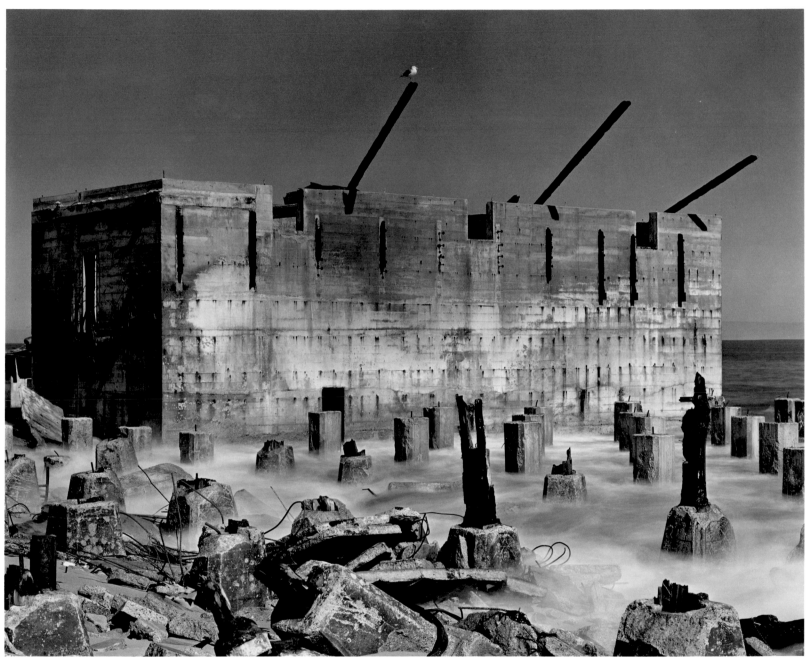

THE BIRD, 1958

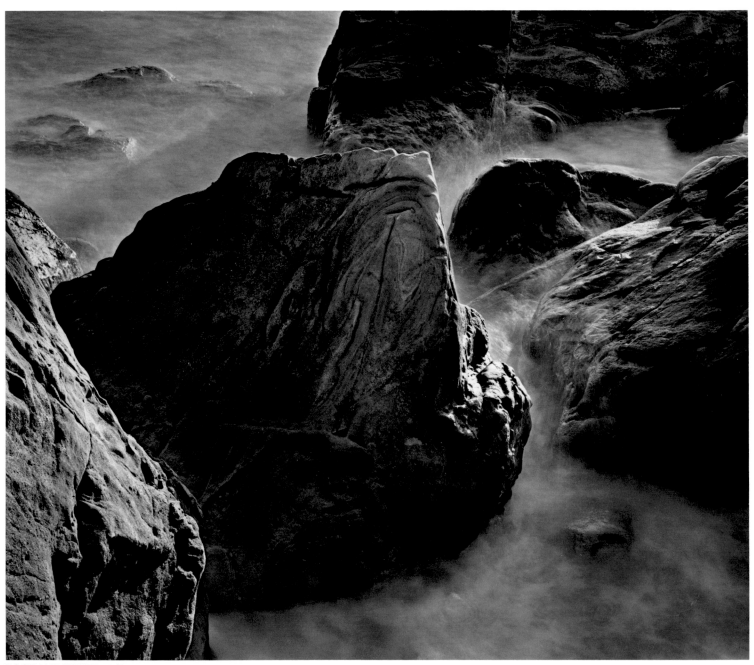

ROCK AND WAVES, 1968

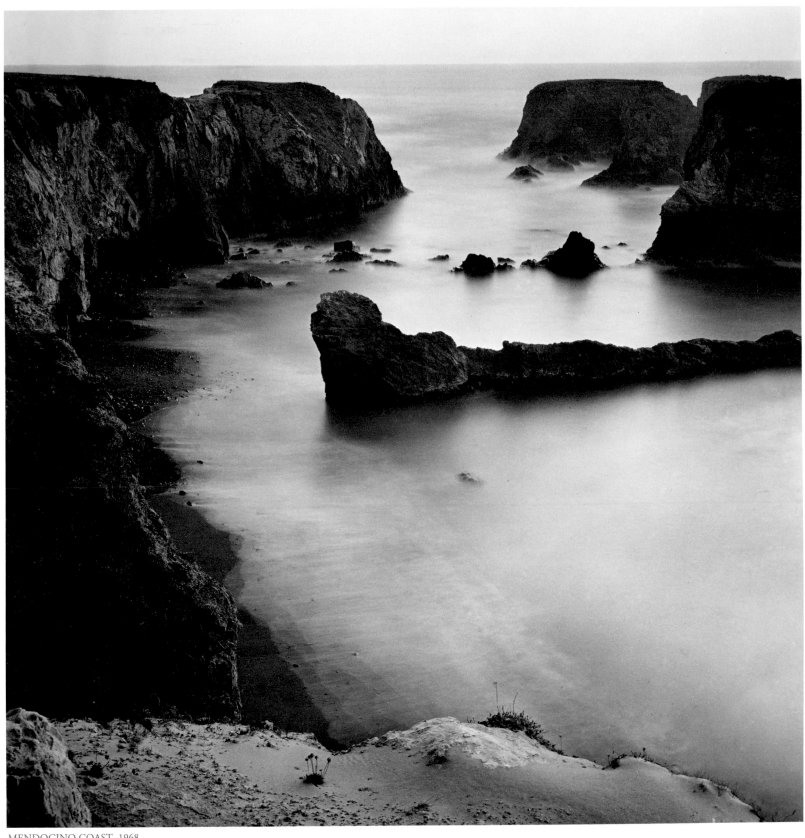

MENDOCINO COAST, 1968

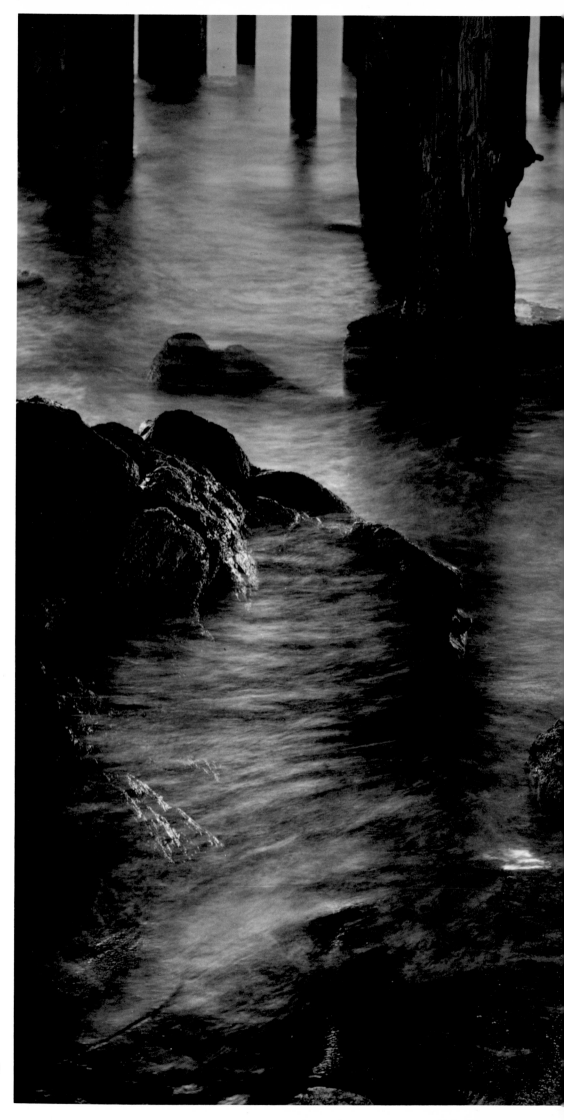

PILINGS UNDER CANNERY ROW, 1958

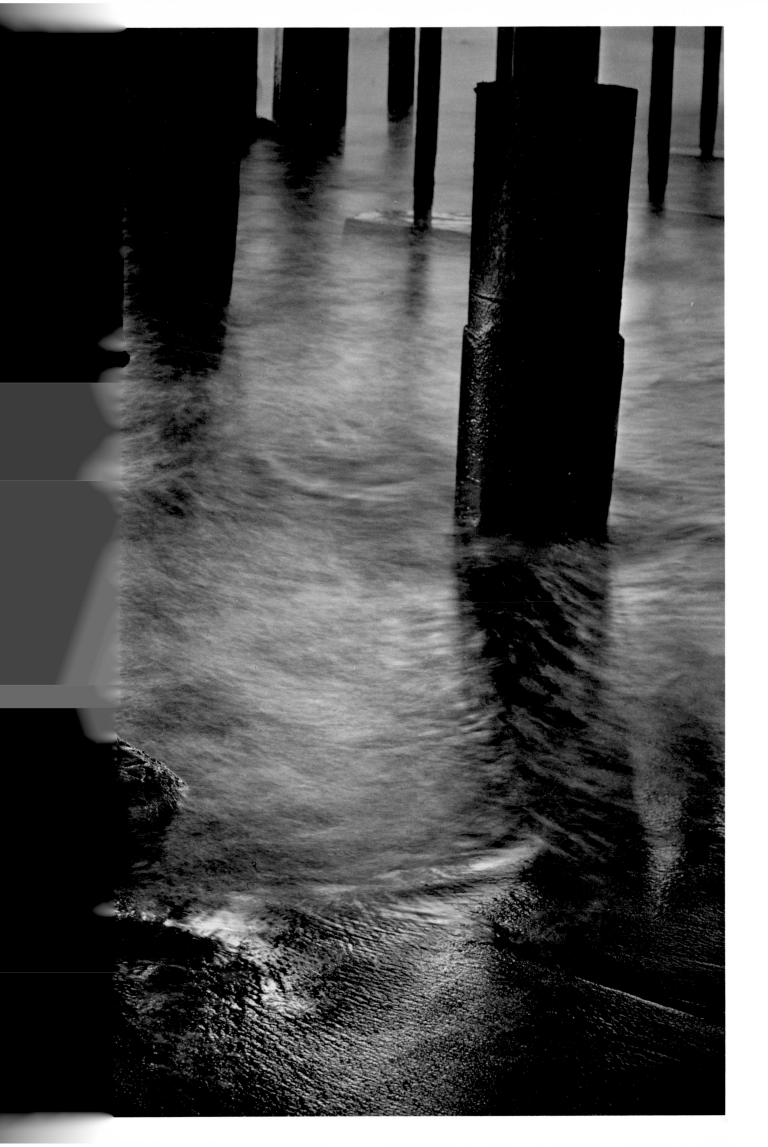

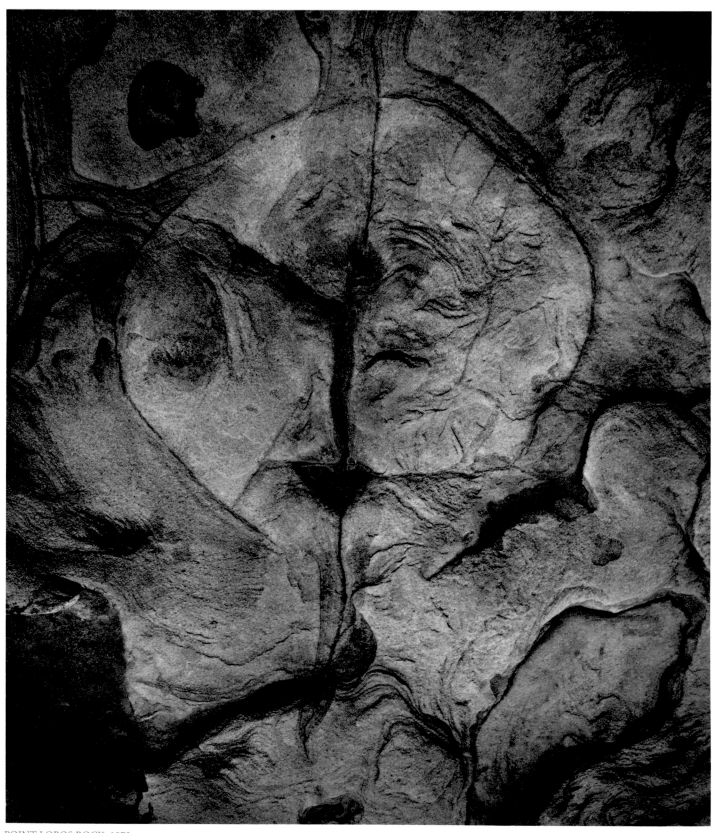

POINT LOBOS ROCK, 1973

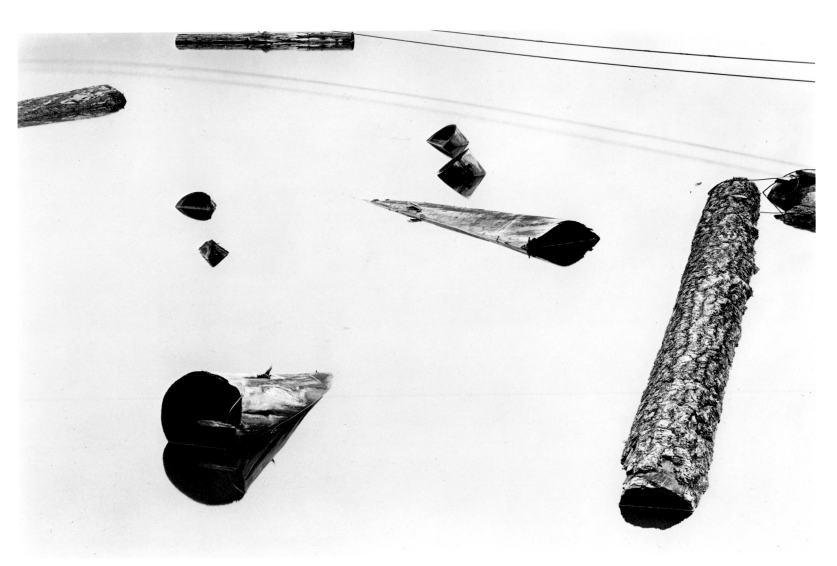

FLOATING LOGS, 1957

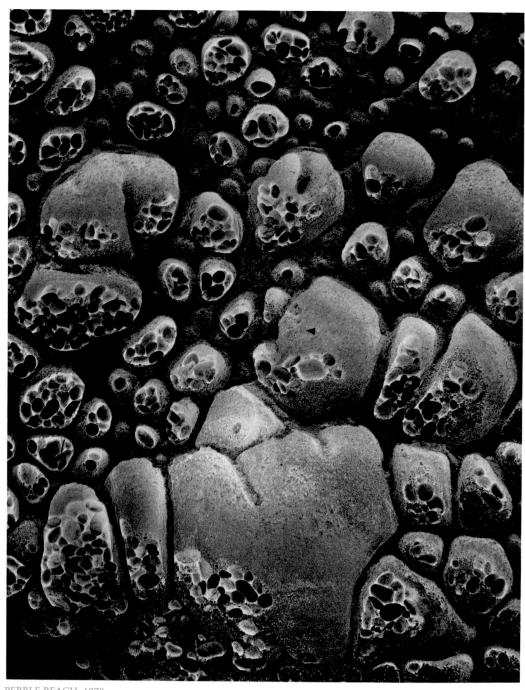

PEBBLE BEACH, 1970

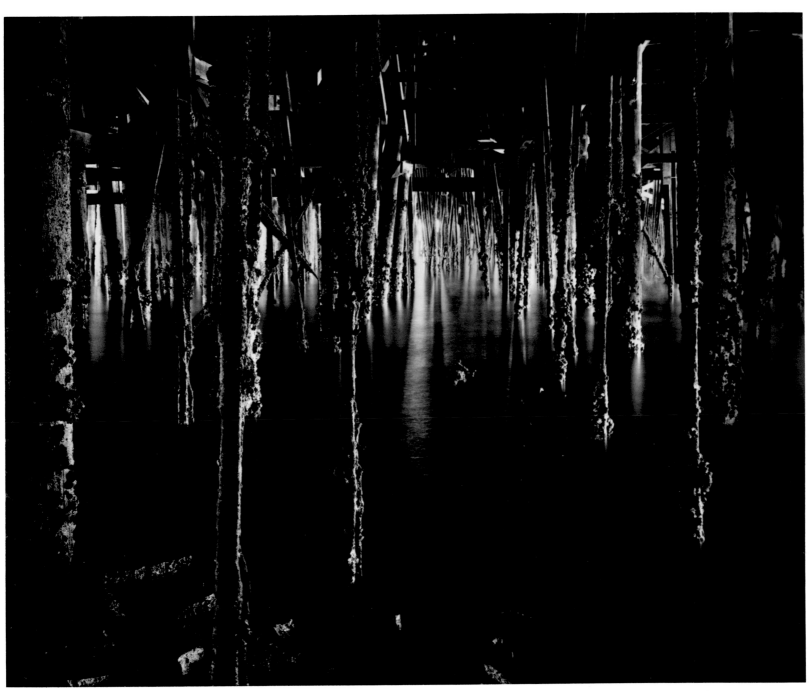

UNDER MONTEREY WHARF, 1969

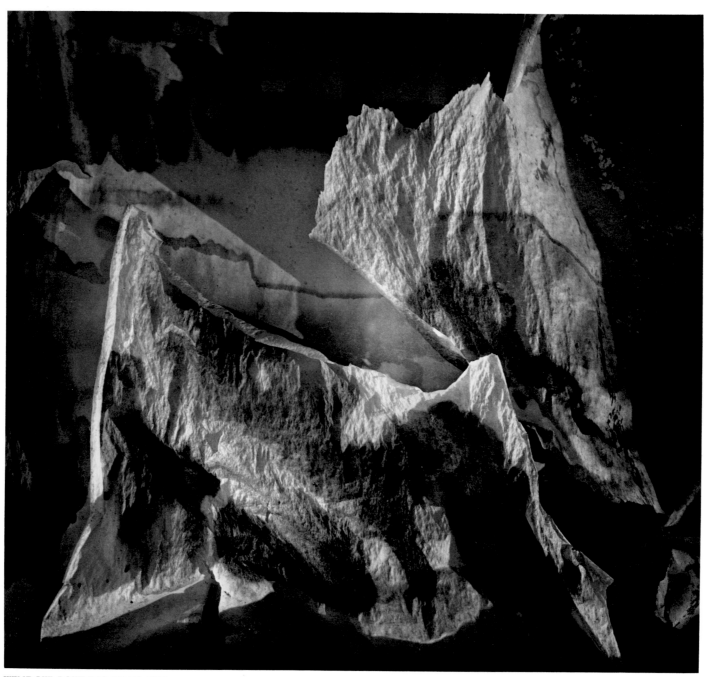

WINDOW, BOWLING ALLEY, 1968

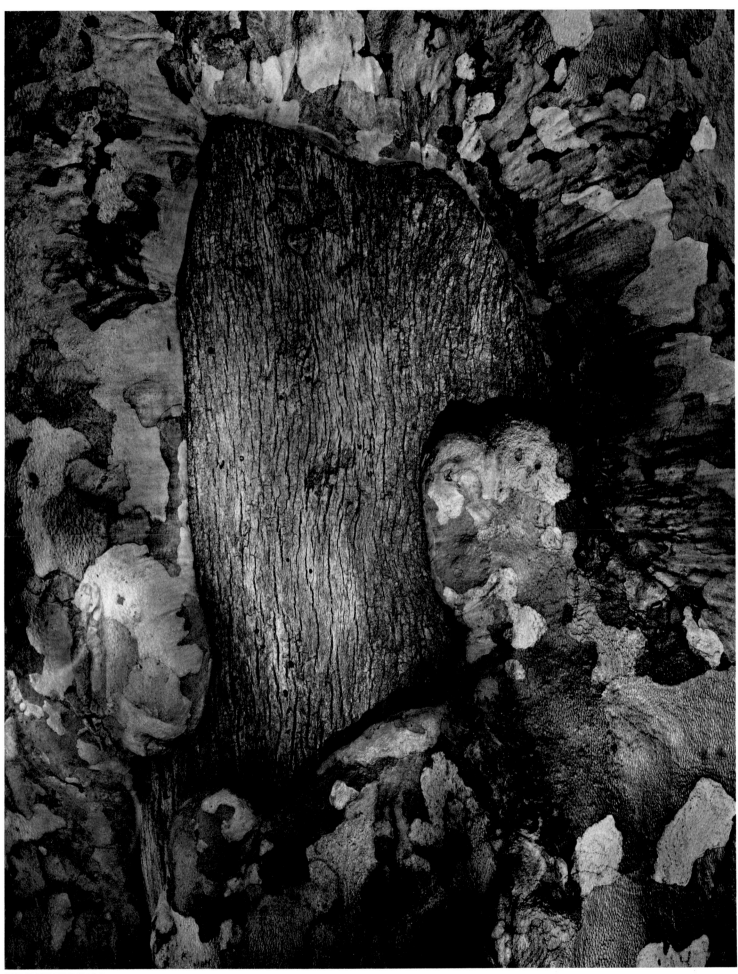

SYCAMORE TREE SCAR, 1971

The strength of photographs as
symbols depends on the universal qualities of
the things symbolized. If they be trivial,
the symbols are trivial. If they be profound,
the symbols are profound, with great power to
endure. Symbols, at their best, not only
serve to illuminate some of the darkness of
the unknown, but also serve to lessen
the fears that too often accompany journeys
from the known to the unknown.

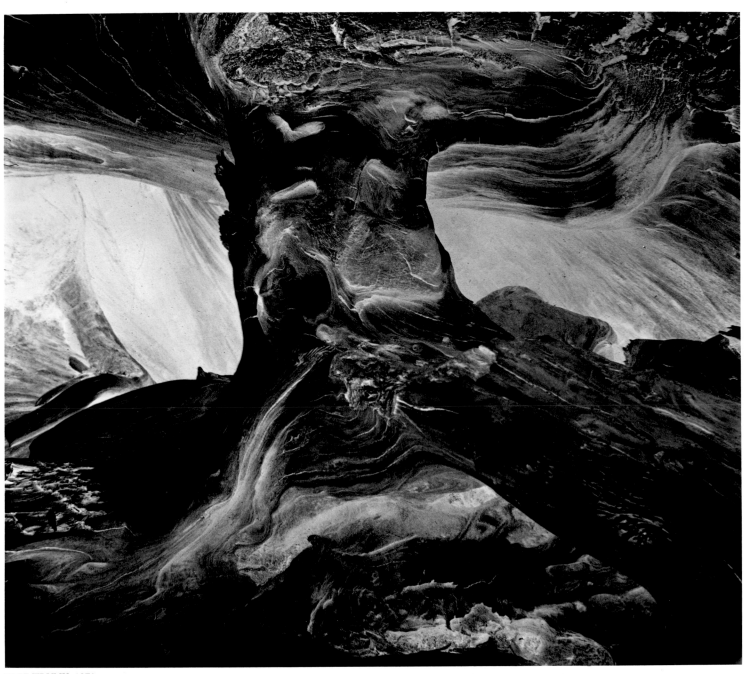

TREE TRUNK, 1971

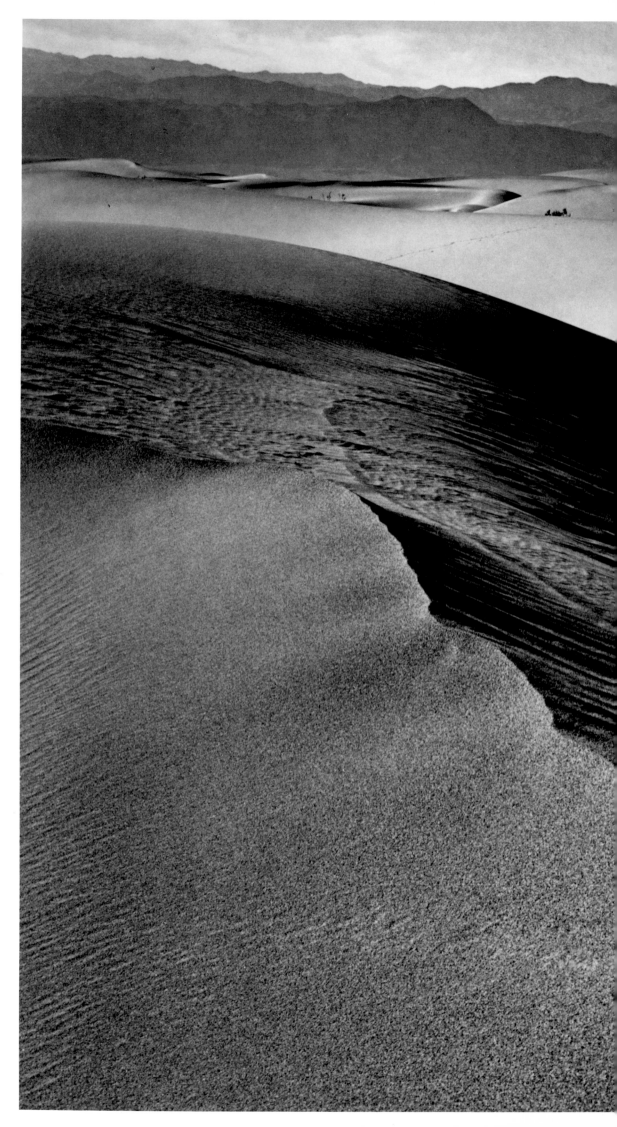

90 DEATH VALLEY, 1940

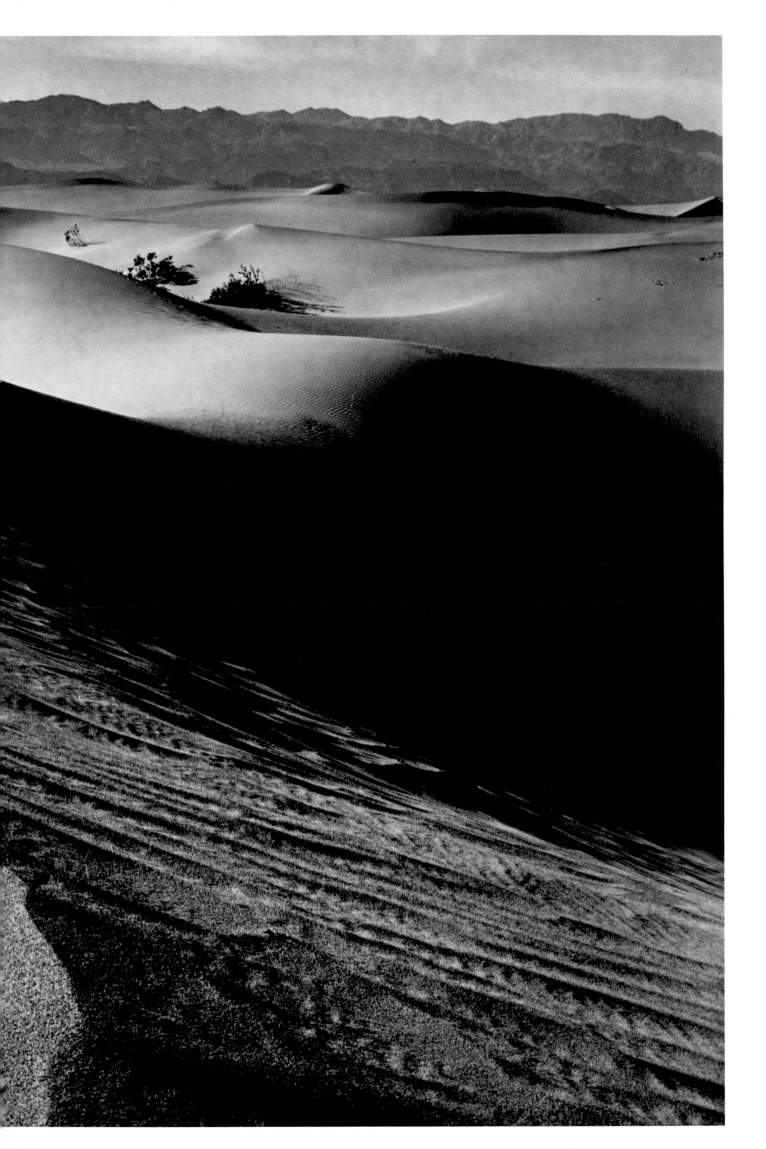

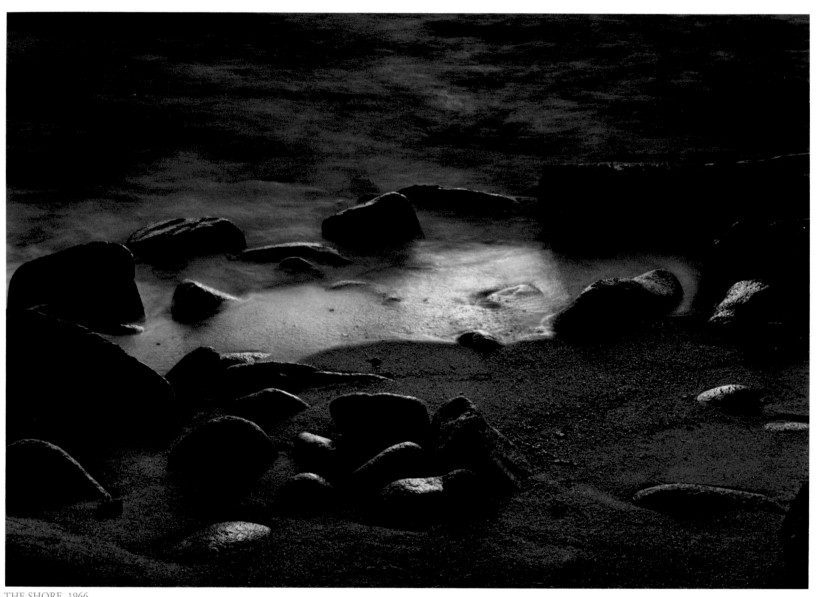

THE SHORE, 1966

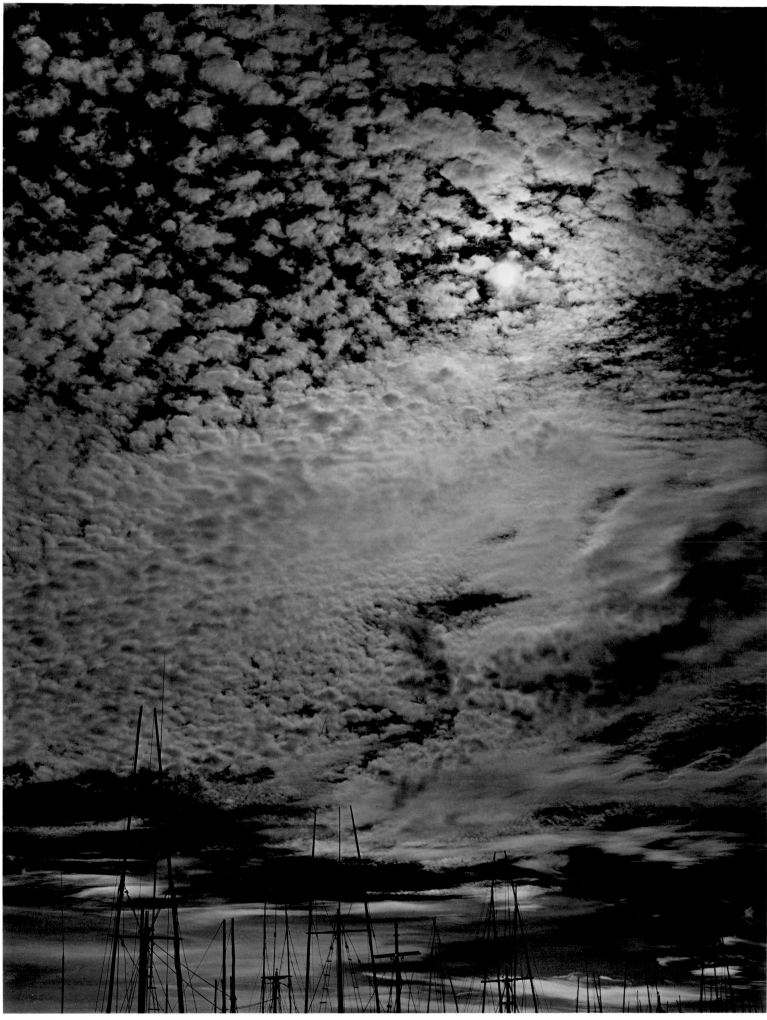

THE MASTS, 1959

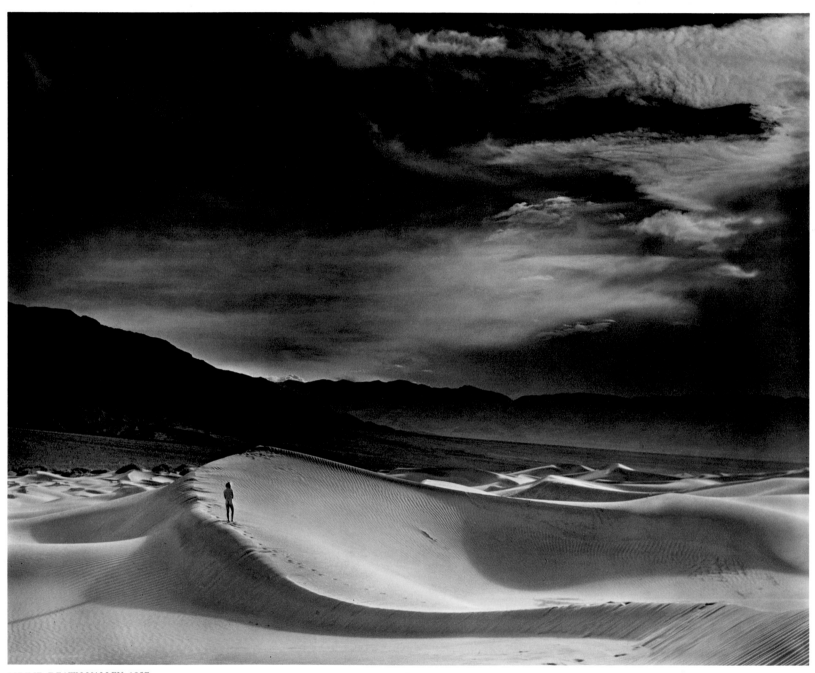

LYNNE, DEATH VALLEY, 1957

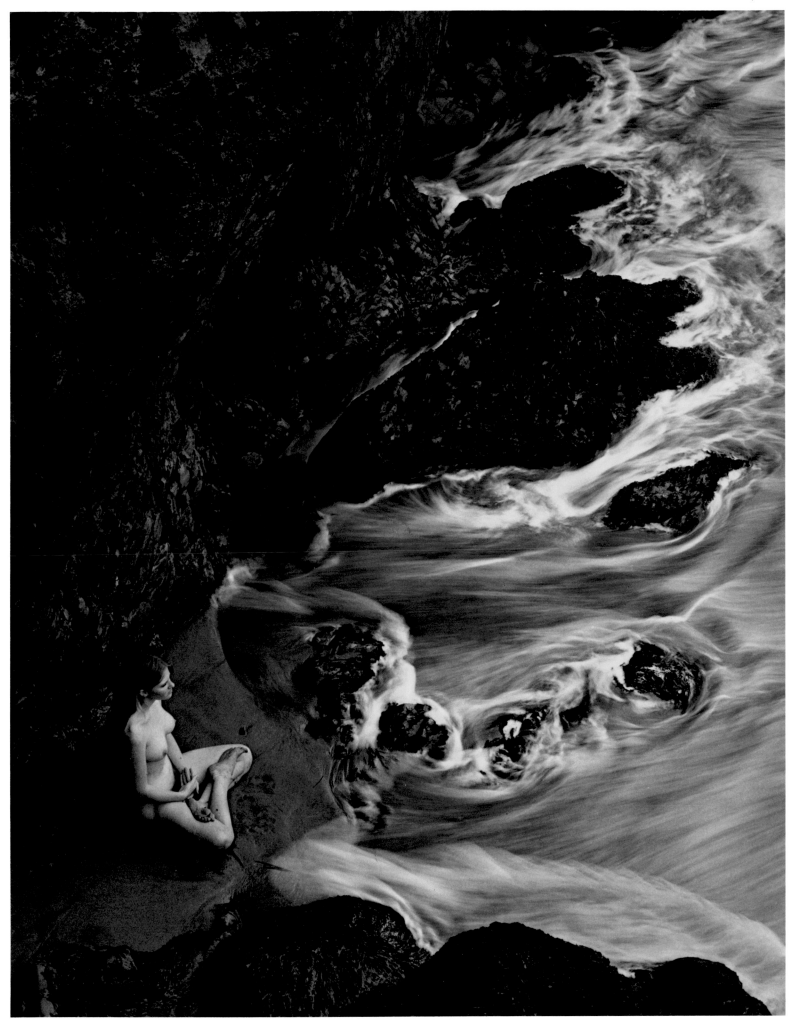

GIRL ON BEACH, 1968

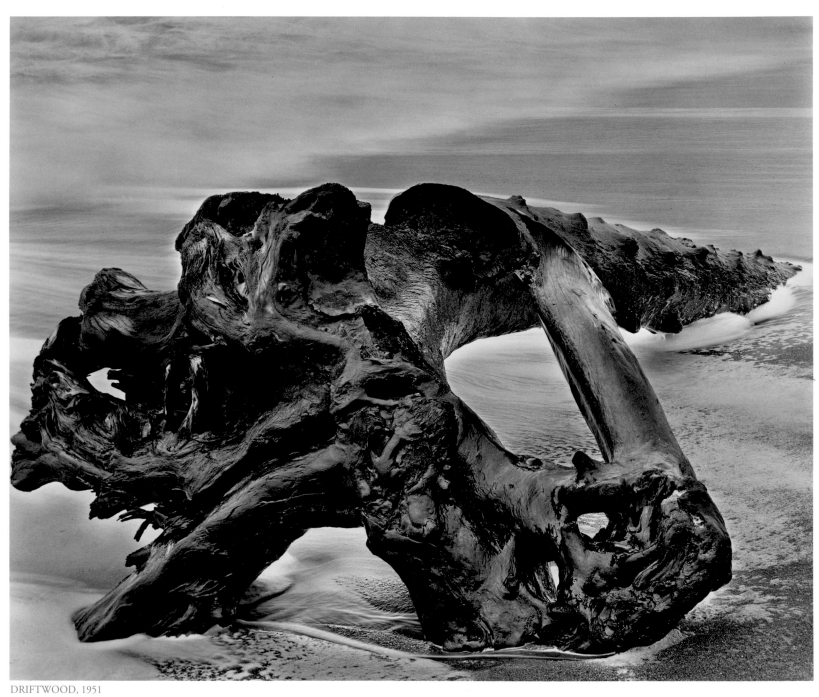

DRIFTWOOD, 1951

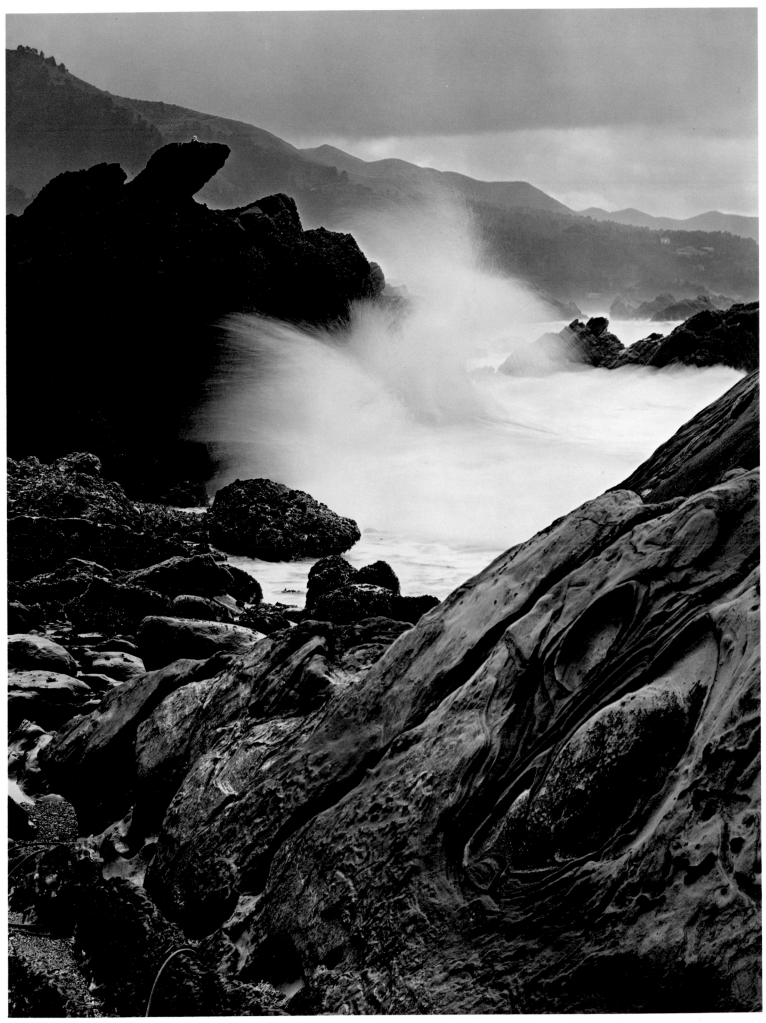

POINT LOBOS WAVE, 1958

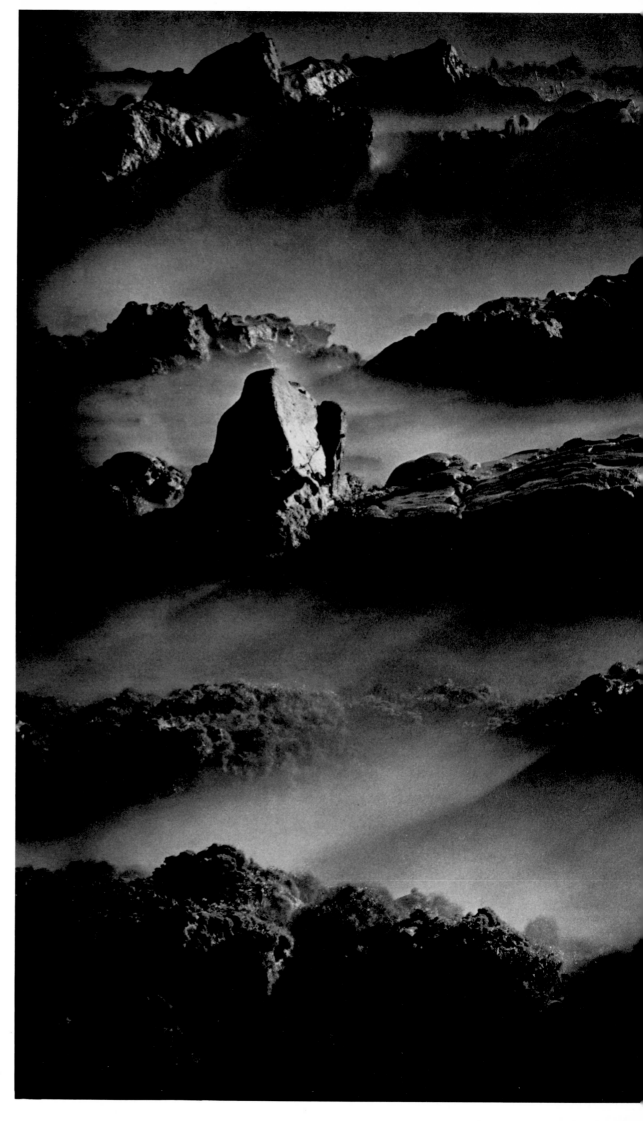

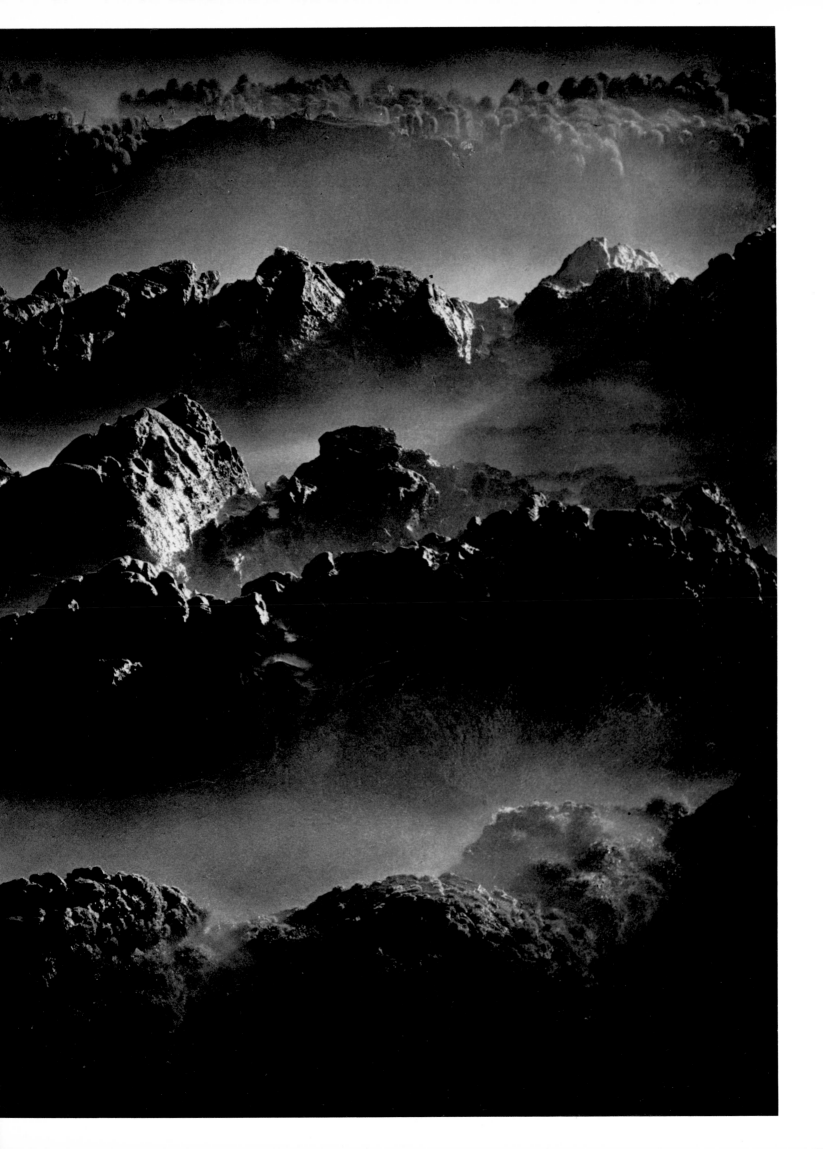

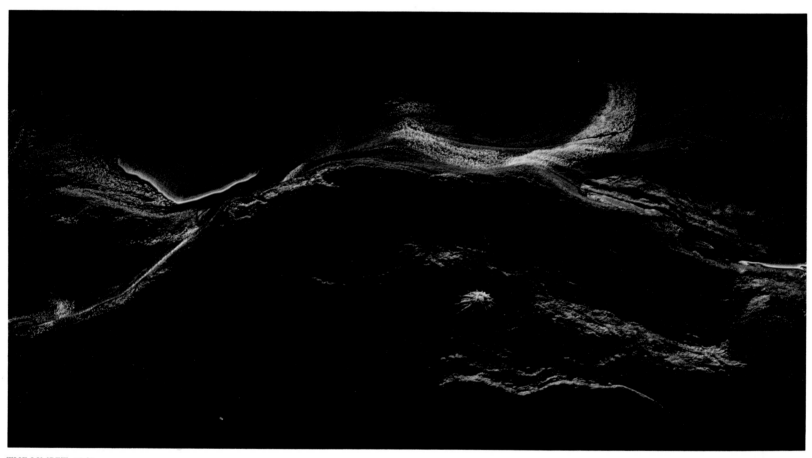

THE LIMPET, 1969

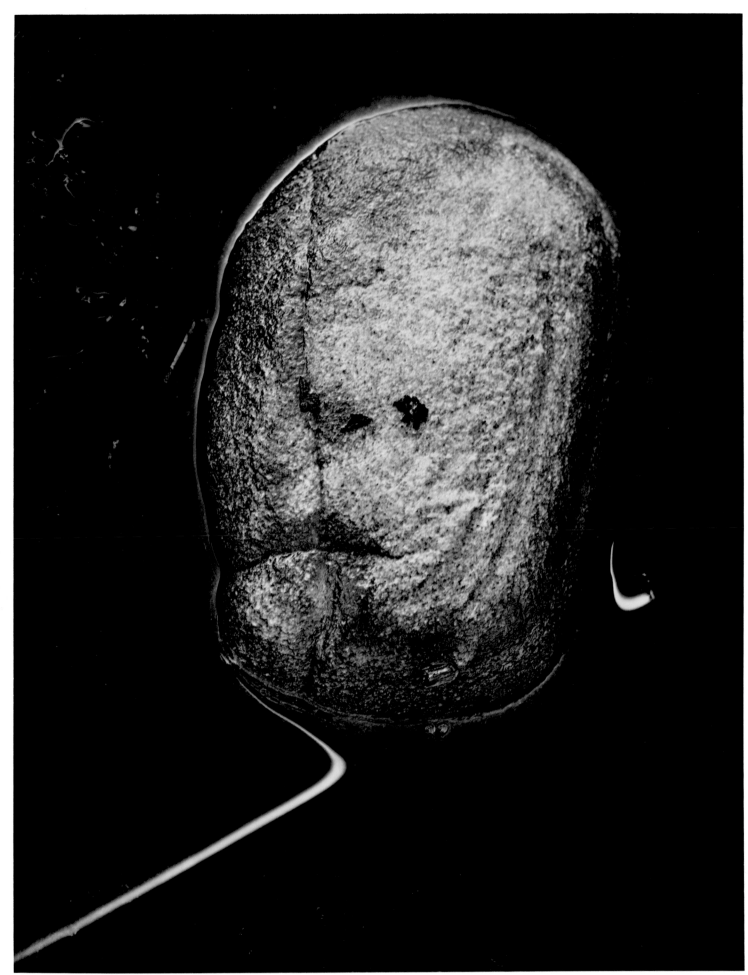

ROCK, 1973

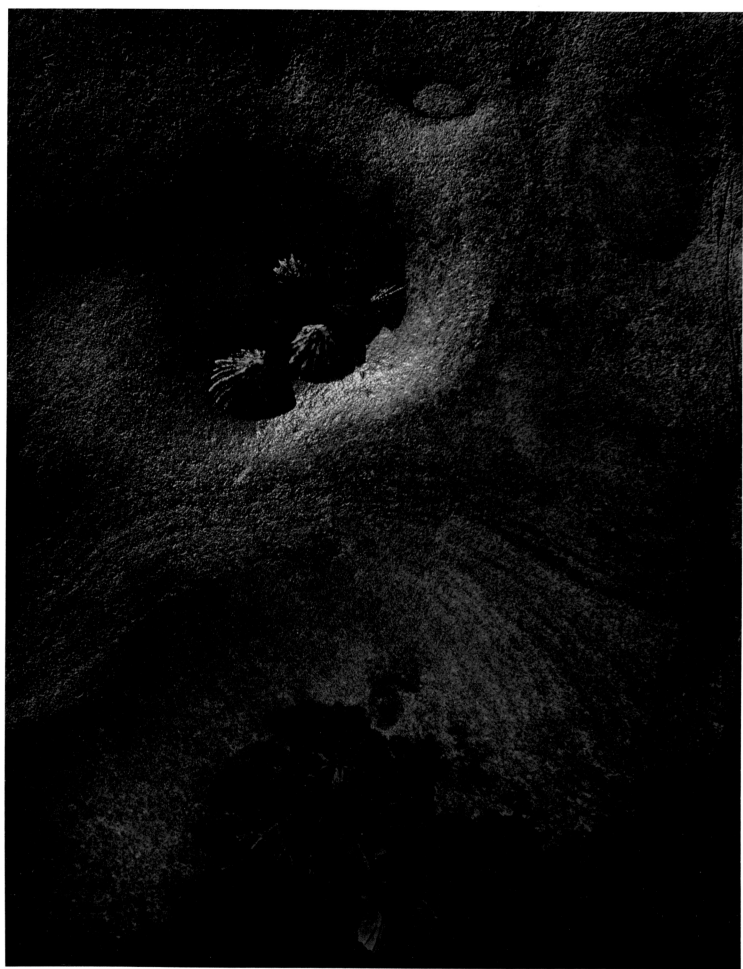

ROCK AND LIMPETS, 1969

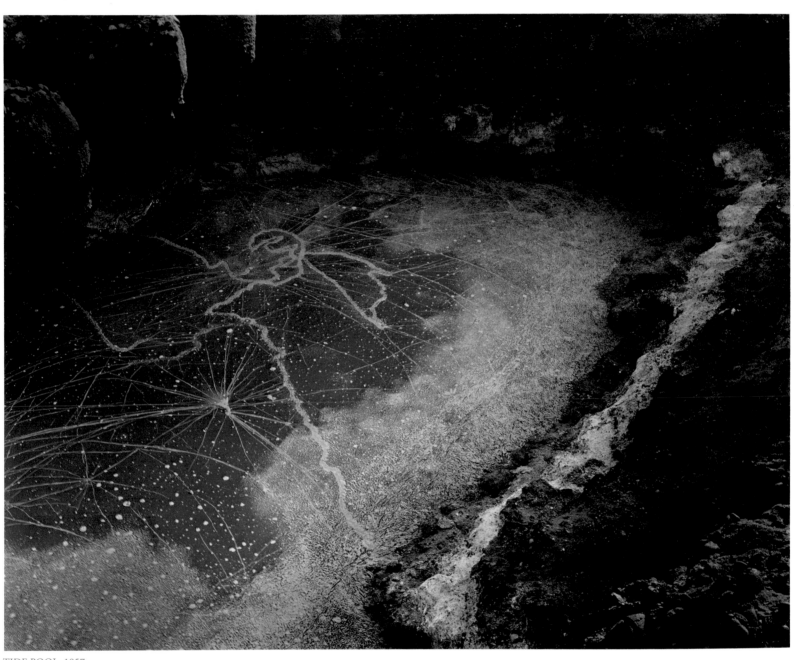

TIDE POOL, 1957

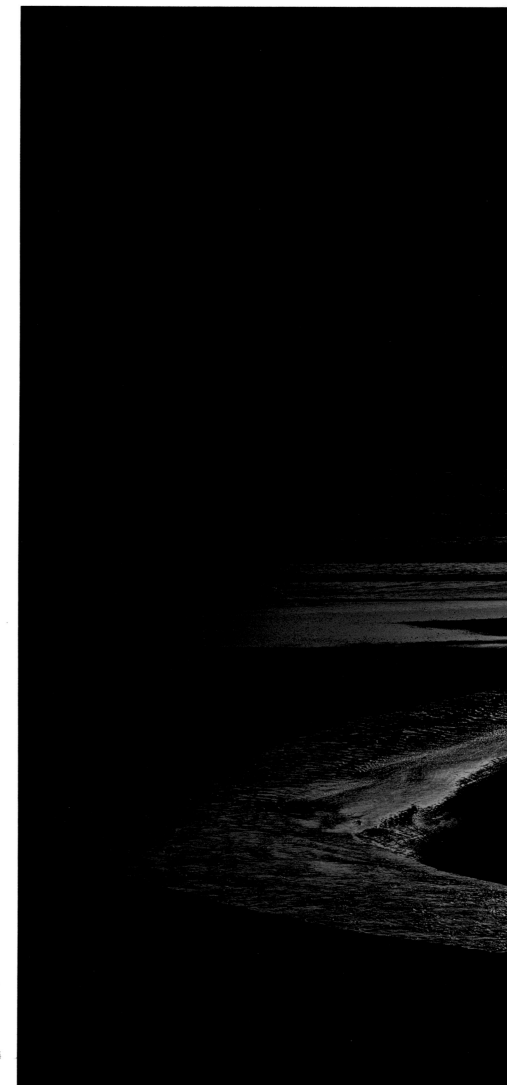

LET THERE BE LIGHT, 1954

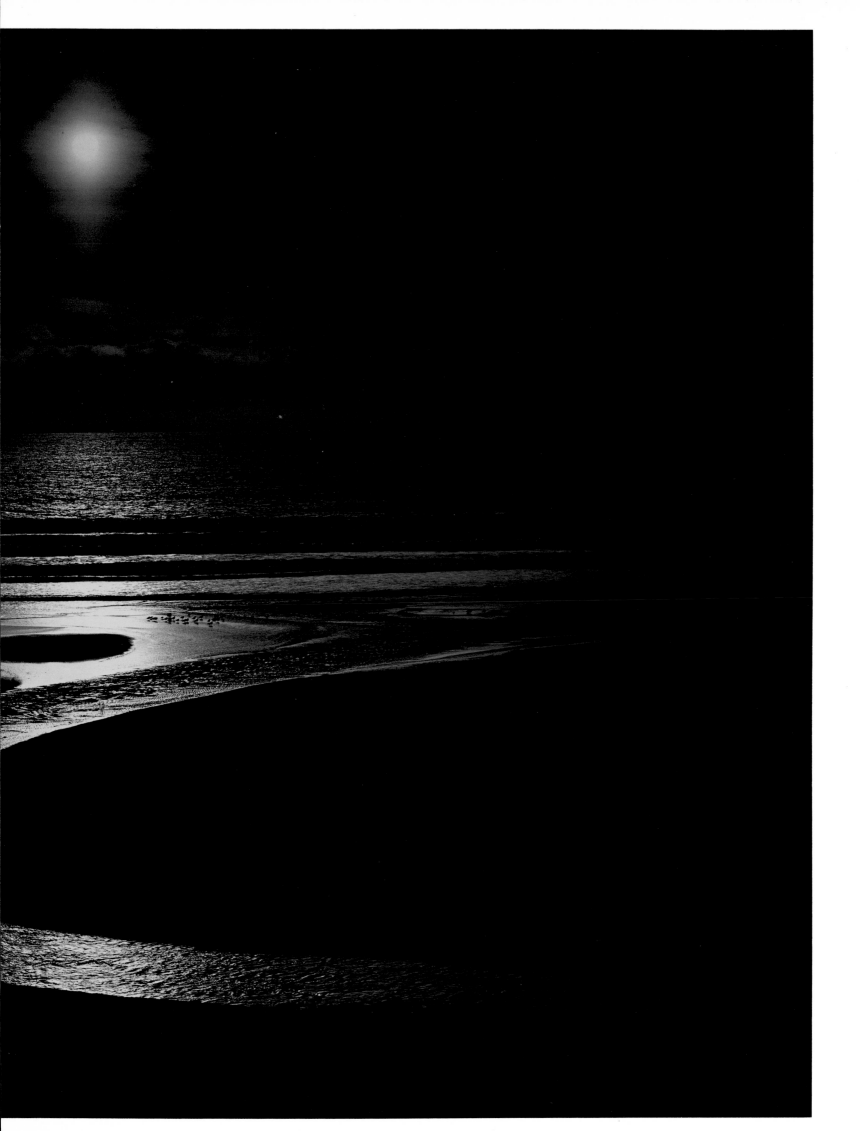

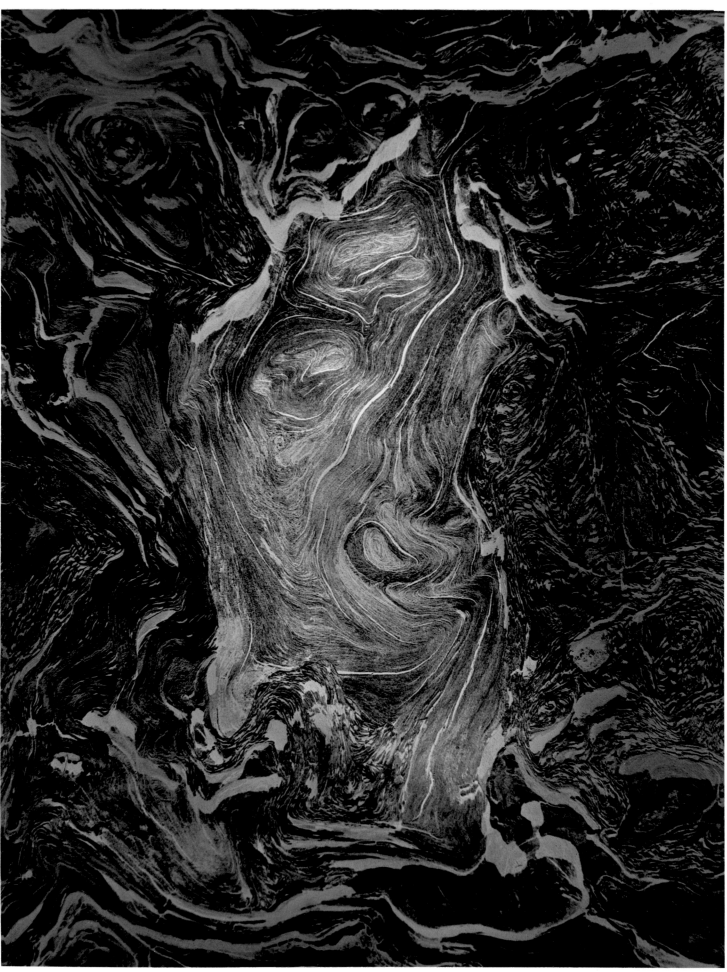

WOOD, 1972

A LIFE OF REASONED PASSION

RAPHAEL SHEVELEV

When the fog lifts, there is a clear view of Monterey Bay from the windows of an unassuming house on the hill. On the other side of the windows a warm and comfortable living room has welcomed a succession of notable guests over the years, including Henry Miller, Brett Weston, and Ansel Adams. Nearby, beyond the kitchen, a passageway leads to a simple room over the garage. It is both organized and cluttered. Boxes of prints are methodically labeled and stacked on one side, adjacent to bookcases jammed so tight that the addition of a single volume would threaten to burst them apart. The rest of the room lies lovingly smothered with papers, more papers, and memorabilia, and on the north wall hangs a beautiful print of *Child in Forest,* 1951 (pp. 20–21). A plaster bust of Wynn Bullock, its mien made comic by an old felt hat, strengthens the impression of his presence. It is here that he came to read, think, and work, and it was from this place that he went to make so many of his memorable photographs.

His artistic conceptions are not bounded by geography, and yet much of Bullock's major work was done in Point Lobos, a few miles down California Highway 1 from his home. Point Lobos was where Bullock went to photograph during the time when he was under the spell of Edward Weston; it was the meditative place where he first began to feel deeply about events in time-space, a theoretical construct that would become a motif in his photographic work. His daughter Barbara Bullock-Wilson wrote, "When he was at Point Lobos, he seemed to feel an extra measure of joy and extraordinary openness, vitality and receptivity....",[1] Toward the end of his life, he worked almost exclusively at Point Lobos, and left a number of striking photographs of which the negative print of an inverted tree, *Tree Trunk,* 1971 (p. 89), is perhaps the best known. It was an image that represented all he believed; it was, in the words of his darkroom assistant Jim Hill, a self-portrait.

Bullock's photographs were the catalyst and evidence of creative thought on the long and difficult road to self-discovery. The challenge lay in exploring the binding force of light as a synthesis between two worlds—the inner world of ideas and the outer world of events—that stimulate our senses. It became a lifelong search for the connection between reality and existence, in pursuit of a vision that "reaches above and below the surface of life."

Wynn Bullock was born Percy Wingfield Bullock in Chicago on April 18, 1902, twenty-one months after the birth of his sister,

Mary, and received his early schooling in South Pasadena, California, where the family moved when he was five. He was a gifted athlete, devoted to swimming, baseball, and tennis, at which he excelled, playing often with the writer Upton Sinclair. There is a 1975 "baseball card" showing him with catcher's mitt, and listing the statistics of his physique, the fact that he "throws: left" and "bats: right" and uses a Rollei loaded with Panatomic-X. He began early to develop his love of the outdoors, of nature, and of light. By the time he had reached his later teens, he had also developed a command of vocal music that enabled him to give his first professional performance at the Hotel del Coronado in Coronado, California.

After graduating from high school, he left South Pasadena and went to New York to study languages, music, and voice, living first in a very sparse room on Fifty-first Street, then moving down the street to a friendlier boarding house "with better food." Two of the occupants there were dancers performing in Irving Berlin's *Music Box Revue,* and they helped him get a job in the chorus, where he earned a comparatively luxurious seventy-five dollars per week. It was an exciting opportunity, and he performed with such popular stars as Fanny Brice and tenor John Steel. One night, when Steel was reputedly indulging his fondness for the bottle and could not go on, Bullock got the chance he had been waiting for and sang the lead. That opportunity was repeated when, again in Steel's inebriated absence, Bullock sang before a packed audience that included President Harding, a flock of the politically powerful, several generous critics, and a very nervous Irving Berlin. Though he refused the part for the first road show, Bullock did sing the New York season with the *Revue* again the following year. At the end of the year he married Mary Elizabeth (Libby) McCarty, who had been taking lessons from the same music teacher. It was a busy life: a new marriage, performances, music lessons, voice coaching, and general liberal arts studies at Columbia University. Then came the decision to go to France.

The Paris that Bullock came to was a mixture of legend and creative genius in the arts. Living close to the Louvre, Bullock and Libby frequently visited the museum. One spring afternoon in 1929, Bullock's steps led him directly to the works of the artistic insurrectionists who had rebelled against the orthodoxy of the Salon, and had organized their own sensational exhibition in 1874, earning for themselves the derisively intended name "impressionists." To one fascinated since childhood by the quali-

ties of light, impressionist paintings held the excitement of intellectual revelation. Close to the end of his life he recalled, still with a sense of wonder, the impressionists' ability to use color as motion. He must have been thrilled by Monet's *La Gare Saint-Lazare*, a painting that suggests the endless dynamic interplay of light, color, smoke, sound, and movement. Throughout his life, he would recall with special pleasure Monet's *Haystacks*, a strangely formal arrangement resembling thatched African huts, one of a series that reflect changes of glowing light. The impressionists' imperative that art should adopt a reality that is felt rather than merely observed resulted in a synthesis of nature and imagination that became increasingly important to Bullock.

Aside from the influence of the impressionists and post-impressionists, Bullock attributed his growing enthusiasm for the visual arts to his introduction to the photography of László Moholy-Nagy and Man Ray. Moholy-Nagy's insistence on developing the primacy of natural visual gifts over specialized skills and his photographs and negative prints later became a source of inspiration to Bullock. For almost thirty years Eugène Atget had been prowling the streets of Paris, making what is arguably the most thoroughly expressive document of urban life. A few months before Atget's death in 1927, Berenice Abbott made an exceptionally expressive portrait of him, in which he has the posture of a tired old man—and the facial expression of an indefatigable seeker.

Man Ray was then at the height of his Parisian prominence, and his enigmatic photograms, later named "rayographs," had gained public attention, as had his visual pun *Violon d'Ingres*, and his unintentionally double-exposed portrait of a now four-eyed Marquise Casati, which his socially prominent subject loved. In the summer of 1929, Man Ray was approached by a beautiful model from Poughkeepsie, New York, who sought to be his student. Her name was Lee Miller, and she became colleague and lover in a volatile relationship. It was Lee who later took credit for an accident that resulted in "edge reversal," later named "solarization" by Man Ray.

In that same summer, Bullock was beginning to receive significant accolades for his musicianship, *La Dépêche de Rouen* reported on June 2: "Bullock is a splendid tenor, the possessor of all the qualities of a great artist." *Journal de Rouen* on the same date declared: "His art is admirable, his musical intuition even more moving. He is Music Incarnate." At about that time, Bullock bought a Zeiss camera, largely for recording snapshots of his European journey. Then he began to develop film in his hotel bathroom, and purchased a very simple enlarger that could produce prints of only one size. In Milan he became familiar with the tenor roles in *La Traviata* and *La Bohème*, from which he was later to take Mimi as the nickname for his first daughter.

Bullock's European sojourn concluded in Berlin, where he bought a Leica and began to become more absorbed by photog-

raphy, pursuing it in the interstices between practicing lieder. His musical studies and, indeed, his career as a professional musician, came to an end a few months after the stock market crash. His family's need for a manager for their business resulted in Bullock's return to the United States.

When the young couple returned from France, it was not to the glamour of a musical life. Libby's family had been quite well off, and Wynn was drafted into overseeing their substantial real estate holdings in Clarksburg, West Virginia. He became a businessman for seven years, apparently doing quite well for such trying times. His devotion to the hobby of photography progressed with the construction of a darkroom in the basement and the purchase of a 5-by-7 Graflex. He was feeling discontent with having been an interpretive, rather than a creative, artist, and began to consider photography as an alternate means of personal expression. Not fully content with the challenges of business and an interest in photography, he attempted to complete college by taking classes at the University of West Virginia. It was during this time, too, that Mary Wynne (Mimi) was born, and, five years later, Bullock's only son, George.

It was in West Virginia that Bullock became acquainted with Alfred Korzybski's book, *Science and Sanity: An Introduction to Non-Aristotelian Systems and General Semantics*, which pleads for a new terminology that would more adequately fuse linguistic understanding with the realities of the physical world, thus creating a more accurate, saner vision of reality. This vision became the seed that would germinate more than a decade later to form the basis of much of Bullock's later theories about symbolism, dimensionality, time-space, radiance, and the notion of "event."

When the business was deemed to be in good enough shape to be handled in trust by the local bank, Wynn decided that he would go to California because he "wanted to have [his] own career." As it turned out, that career became a lifelong passion for photography, but not before he made a happily aborted attempt to study law at the University of Southern California Law School, where his mother, Georgia P. Bullock, had studied. Georgiana Philipps Morgan was born in Chicago, the daughter of a Welsh father and a Connecticut mother. She married William Wingfield Bullock, about whom little is known, in 1899, and obtained a divorce in 1909, when Wynn was seven. Determined to excel in law, she acquired her LL.B. in 1914 and her LL.D. from Southwestern University in 1915, and in 1931 became the first woman Superior Court judge in California. From then on, she insisted on being called Judge, even by Edna and Wynn and Edna's children.

One day, utterly frustrated with the study of law, Wynn abandoned his books and the classroom at the law school, and strode down the street to enroll at the Los Angeles Art Center

School. After a remarkably short and intense two years there, during which he pursued technical excellence and experimentation, particularly in solarization, rather than philosophical artistic insight, he graduated in 1940.

Upon leaving art school Bullock had the opportunity to study directly with Alfred Korzybski in a course the latter was then giving under the auspices of his Chicago-based Institute of General Semantics. It was 1941, the year in which Bullock's work was exhibited at the Los Angeles County Museum of Art, which was his and the museum's first one-person photography show. During the same year, he divorced Libby. The marriage had become progressively difficult, and at times Bullock drove himself so hard that it depleted him physically and fueled the false suspicion that he might have leukemia. There were occasions when Libby, who thought his passionate devotion to photography a waste of time, went into the darkroom, snatched prints out of the hypo, and destroyed them.

In 1942 Bullock enlisted in the army, and was sent to a base near Fresno, California, for basic training. Together with his sister, Mary, he had recently become the managing partner of a business handling the photographic needs of Camp Cook (the site of the present Vandenberg Air Force Base near Santa Maria), later buying Mary out and retaining the business interest while in the army. Teaching in a public school in Fresno at that time was a young woman by the name of Edna Jeanette Earle, daughter of the police chief of Hollister. Edna the tomboy had grown into a vibrant, intelligent, and loving woman. Mutual friends tried to play matchmaker, but Edna resisted, reluctant to consider an older man, divorced, and with two children. She did, however, conspire to get a look at him at a bowling match, and liked his appearance. When he called her for a date, introducing himself as Wynn, it took most of the conversation before she realized that Wynn was the same person as the Percy she had been told about. Their first date, in November 1942, was at a boxing match. They were married soon after on February 13, 1943. It was an especially life-affirming moment for Wynn, after the pain of his first marriage and the death of his young son. George, born a healthy baby, seemed progressively affected by the tensions between his parents and increasing fear of his mother, who had insisted on including the children in arguments with Wynn. By the time he was six, he had developed ulcers and seemed to be wasting away. He died at seven from complications arising from the treatment of a bleeding ulcer. Shortly before his death, George wrote a loving note to his father, who carried it with him for the rest of his life. Of his marriage to Edna, Wynn would later say, "From that moment, everything went on the up."

In the fall of 1943, Bullock was allowed an honorable discharge from the army to work as a photographer in the defense industry, first at Lockheed and then at Connors Joyce in southern California, where he and Edna found an apartment in

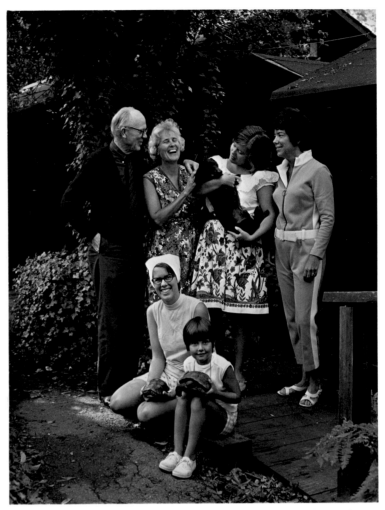

PORTRAIT OF THE BULLOCK FAMILY, C. 1960. Back row: Wynn, Edna, Barbara with Hapi, Mimi; front row: Lynne, Liz, and tortoises. Photograph by Todd Walker.

Burbank. After a year, they moved to Santa Maria, where Wynn continued his work in the portrait and photo-finishing business. After his second daughter, Barbara, was born in 1945, Wynn and Edna bought a trailer in which the family traveled up and down the coast doing commercial scenic postcard work for motels and the Greyhound Bus Company. It was on one of these trips that they discovered the beauty of Monterey, and shortly afterward, through Georgia Bullock's influence with army brass, Wynn secured the photographic concession at Fort Ord and the family went to live in a trailer park in Monterey. In 1947 Wynn and Edna bought a lot on the hillside overlooking Monterey Bay. There they built the house that is still the Bullock family home.

Somehow, Bullock was able to segregate successfully his commercial photography from the artistic work that kept him absorbed when not at Fort Ord. He had always been able to focus with great concentration on the work at hand, which had enabled his musical and business careers. He applied that eager concentration to a continued study of solarization, which was to culminate after eight years of research in his receiving U.S., British, and Canadian patents for the "Photographic Process for Producing Line Image," or control of the line effect in solarization. At first he

found the absence of teachers frustrating, noting that "a few well known men in Europe such as Man Ray and Erwin Blumenfeld have done fine work in this field, but I know of no one in this country capable of teaching the subject. I, therefore, had to continue my studies by myself." He proceeded to carry the study of the control of solarization further than anyone else had, and was eventually to receive a second U.S. patent on "Methods and Means for Matching Opposing Densities in Photographic Film." He had defied the skeptics, who found it unbelievable that one could be awarded patents for an essentially artistic process.

In 1950, writing notes for his own use, Bullock marked the occasion as his tenth anniversary of working as a professional photographer, then wrote about his pursuit of controlled solarization. Scribbling some thoughts on that very same piece of paper twenty-one years later, he reaffirmed his conviction about the uses of solarization, adding that it is "capable of striking images, but too derivative of modern painting." Then, conscious once again of the relationship between positive and negative in that process, he was moved to write on the periphery of the page, "sometimes this reversal which is what the camera 'sees' causes both space and time changes that give to the negative print stronger meaning than if it were a 'positive' print." The handwriting continues with a statement about the new center of his concentration in the seventies: "My principal interest now is work without constrictive darkroom devices while at the same time developing my eye to truly accept either negative or positive images."

DEAD BUSH AND BEACH ROCK, 1953

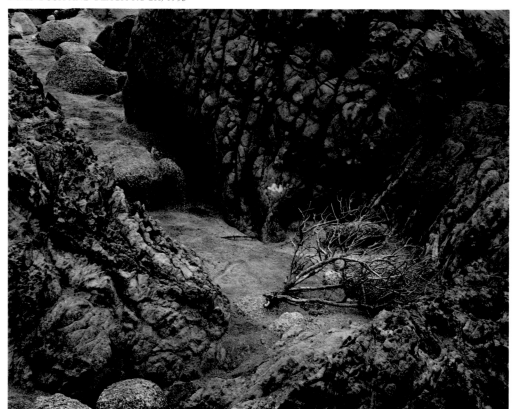

In 1948 Bullock met Edward Weston, and this meeting had an important impact on the direction of his work. After almost a decade of arduous technical experimentation, it heralded a move toward the "straight print." In America generally, the years immediately after the end of World War II were "characterized by…domestic peace, political conformism, and expansive consumerism, [and] many in the arts began to grapple with problems of pure form, with the expression of inner visions.…"[2] Minor White was advocating that photography be used not only to reveal the objective qualities of things, but also their mystical qualities. By often making images without scale or geographic reference, White had been able to endow his photographs with a sense of feeling to match the forms. This sense of feeling was central also to Weston's images, achieved by a prodigious control of form, light, and tone, and notably by replacing the remotenesss of an approach solely to the object with the intimacy of a relationship to the subject.

At the time Bullock met him, Weston had contracted Parkinson's disease. It wasn't very far advanced, but Weston was unable to photograph, though he was able to receive visitors and talk. Bullock wrote how Weston revealed "that the straight photograph was a means of expressing the world in a way that no other medium could express it…it was his tonal quality, the fact that you could photograph something and it became more than just a copy.… I began to realize that you could take pictures and they didn't have to be copies."

For the next two years Bullock became an "Edwardian," taking photographs in the same areas where Weston had been working for more than a decade. He discovered what equipment Weston was using, and purchased the same kind of camera, film, paper, and chemistry. Then he realized that he was acquiring someone else's technique without acquiring the accompanying vision. He instinctively saw that some of Weston's photographs made "more of an object than an object" but at that point did not choose to analyze what that meant. Later he ascribed it not to some kind of objective enhancement, but rather to the evolution of the artist's subjective visual enhancement. "Weston," he later wrote, "gave me great respect for the pure photographic image, for the marvelous tonalities that a great photograph can have. In experimental work these beautiful tonalities rarely, if ever, exist." He was less attracted by Weston's words than by his photographs, complaining that "some of his best-known sayings don't make any sense at all."

The evolution away from Weston began with a philosophical need to make the perception of an object a more active process and to see objects as events inextricably bound to spatial and temporal relationships. He rejected the distinction between positive and negative space, claiming that "all space is positive." Though deeply appreciative of Weston's abilities with light, space, and tonality, he added that Weston "did not have a highly developed perception of the time dimension that gives profound meaning to photographs." To this remark he added:

A symbol is anything that stands for anything else, so I began to accept the fact that photographs could symbolize events as well as static objects. And the only way to possibly symbolize events is through relationships. If you isolate the thing…then it becomes how it was at the moment that you photographed it. But if you relate it to other things, one can evoke their temporal qualities.[3]

Bullock's developing insights and convictions at the time of his separation from Edward Weston grew out of the seeds planted in Bullock's mind by his exposure to the work of Alfred Korzybski fifteen years earlier. Among the principles that Bullock espoused was the unity of space and time, derived by Korzybski from the fundamental work of Hermann Minkowski, who is credited with forming the mathematical foundation for Einstein's relativity theory. Korzybski postulated space not as a vast Euclidean emptiness, but as a *plenum*, a fullness, "structurally preferable and semantically sounder and more in accord with the structure of the world.…" Indeed, as a semanticist, it became vital to Korzybski that we use language, and therefore concepts, that more closely mirror objective reality. Deeply conscious of the nature of symbolism, and therefore the distinction between the words we use and the things they describe, he wrote, "In our brief verbal analysis of 'space,' 'time,' and 'matter,' we have seen that these represent *terms, or linguistic means, not objects.…*They introduce a verbal *elementalism* structurally *absent* in nature, and by a process of objectification lead to many kinds of semantically harmful metaphysics." Matter, space, and time are not objects, they are words invented to enable possible abstract elemental thinking. Further, they are inseparable in nature, because matter can only happen in space and in time. That unified happening is signified—symbolized—by the word "event."

This, then, was the philosophical basis upon which Bullock constructed his own thought about space-time, event, and symbolism, which he refined throughout his life as a means by which to enable his own vision and understanding. In a 1970 essay Bullock summarized these precepts:

Space is finite. Without objects to perceive, space has no reality. It is a form of perception.…The visual qualities of any object are only spatial and are deeply concerned with the relational character of the three dimensions:

line, plane and thickness. Space is fullness. All physical matter, whether solid, liquid, gaseous, or electromagnetic is spatial in character.[4]

Bullock worked diligently at adapting each of his abstract principles directly to the practice of his art. About the fundamental issue of dimensionality, he wrote:

For purposes of expressing these dimensions photographically, I'll define the three dimensions in visual terms as follows: the first dimension is line, shadow and silhouette; the second dimension is texture; and the third dimension, form. These dimensions of the physical object are related to what exists in nature, and what one perceives and reacts to. Connected inseparably with these three ascending dimensions of physical reality is still another which has deep meaning, that is space.[5]

These personal explorations into the metaphysics of perception represent both a self-discipline for personal enlightenment as well as a guide offered to others:

I feel…very strongly that all photographers interested in creative expression should be consciously aware that these dimensions are a measure of reality, and their dimensional progression is a law of nature. Whether one wishes to express fantasy or reality, the principle expressed is needed as a *reference point* for whatever creative direction one wishes to take. This is not an intellectual device but an understanding to aid our perceptual seeing in photography.[6]

This "reference point" of dimensional reality is the stage from which the photographer can set a course for a journey beyond the "static world of appearances" and "express the inner realities of the world of nature." At this juncture Bullock fuses the elements of dimension, their inescapable place in the fullness of space, to the necessity of time, which "has no independent existence apart from the order of events that measure it."

Korzybski's deceptively simple caveat that the word is not the thing and that our perceptions are not the same as the events being perceived was the semantic counterpart to René Magritte's 1926 painting of a pipe, labeled *Ceci n'est pas une pipe*, and the source from which Bullock derived his principles of the nature of the photograph-as-symbol. The creative act with which he was most concerned lay in the ordering of the relationships between the photograph-as-symbol and the things symbolized in ways that endow the symbol with credibility and meaning. He drew an important distinction between the way symbolism affects the photographer and the way it appears to the viewer. For the viewer, photographs-as-symbols are the primary sensual stimulus, whereas the things symbolized are secondary because they are absent. For the photographer, things perceived are primary,

whereas photographs-as-symbols are secondary; things perceived have the value upon which the photographs-as-symbols depend.

Bullock's goal was a conceptual journey that encompasses more than those things we readily perceive with our limited physical senses, time being perhaps the most important. Without events to mark it, there is no time, and time, being associated with faculties of memory and reason, relates to changes in the visual qualities of things.

Though in the 1950s Bullock made a number of other significant images, that time is often referred to as his "nude period." The critic Margery Mann wrote: "In his conversation, Bullock takes a more purist line than he does in his work. He will occasionally deplore contrivance, and he praises the power of the real. But his prints are made with whatever means he thinks necessary to present his message."[7] This remains especially alive in the memories of his three daughters. Barbara, the child in *Child in Forest*, remembers the discomfort of the dry leaves and nettles beneath her reclining body. Lynne, who was born in 1953, now with forgiveness remembers what caused her to cry in *A Child's Grief*, 1955: a lizard, creeping toward her, out of sight of her father, who ordered her to stay put. She recalls going on a picnic and then automatically disrobing to model for Dad; when she was told that her father would not be photographing that day, she broke into tears and was quite unhappy about it.[8] Mimi, with wry humor, recalls Wynn posing her next to a cactus, and, when she fainted from the heat, he revived her, and propped her up again!

Edna and the three daughters remember Wynn as a husband and father of great wit, who admitted enjoying "quality pornography," and could be fiercely competitive. He was known to have upset the card table after losing a game and to being less than gracious about losing at tennis and golf. He was also a man of intense passion, and those who conversed and argued with him about his ideas remember how, in the throes of advocacy, he would quiver with an excited intensity. Friends remember a loving and attentive man, and this is reflected in the quality of his correspondence with those sharing his passion for insight. His letters to a young friend, Eileen Berger Kitzis, are characteristic: "…what moved me most was that silent communication that goes beyond words."[9] For some friends, the intensity of his unsilent communication caused them occasionally to avoid him, though photographer Ruth Bernhard remembers him as a "gentle and spiritual man." Former student, now noted artist, Chris Johnson, recalls Bullock with deep appreciation as "a man who not only thought deeply about the philosophical implications of art and life, but was able to produce a unique body of work that not only demonstrated those ideas, but, more importantly, showed that the convictions were indispensable to the photographs."

Bullock enjoyed a close and mutually respectful relationship with his models. Sir Kenneth Clark has written that an element of eroticism in the making of images of nudes is not only unavoidable, but is an active and essential element that is necessary to art. When presented with this statement, Bullock's first response was ambivalent, appearing to retreat defensively from an "accusation," while acknowledging some morsel of truth in Clark's statement. Later, after some thought, he admitted that "I could thoroughly enjoy the beauty of the sensual body, and I'm sure it aroused erotic ideas in my mind. But the most important thing was the picture.… If I thought that afterwards we'd have a session of sex, I'd never on earth keep my mind on the picture."

The nudes are not portraits, but incorporations of the grace of the unclothed human body as a natural element in a wider scene. They were the result of searches for a suitable environment long before the model appeared. It was a happy search, that took Bullock into valleys of the Big Sur, into the wild country he loved. "In such an environment the human figure, the trees, plants, ferns, and the cabin, if I include it, manifest the cyclic forces of life and death in various stages.…When I am in the forest with a model, I work…to record not only what I see but what I feel." He consciously tried to symbolize the object qualities of the forms and textures of the body together with those of its surroundings, in an attempt to show not only the meaningful spatial relationships, but also a sense of a shared destiny in the passage of time.

Of all the nudes, there are three that are especially distinct from the others, and yet at total contrast to one another: *Lynne, Death Valley*, 1957 (p. 94), *Edna*, 1956 (p. 28), and *Stefan*, 1954 (p. 113). The first is a phenomenally luminous portrayal of a very small, vulnerable human figure in a very large scene in which environmental forces are highly fluid, threatening change even as one looks at the print; *Edna* is a very close and very dramatic depiction of the intense power of the human body, devoid of a relationship to physical environment; *Stefan*, a rare male nude, shows an infant's body, glowing out of the background of somber indoor tones, topped by a head that seems to belong to an adult deep in thought. All make full use of the power of light, lending dramatic credence to Bullock's poetic conviction about the radiant emanation of light from other than conventional light sources. This luminous character of Bullock's photography is most dramatically demonstrated by such later work as *The Shore*, 1966 (p. 92), and *The Limpet*, 1969 (p. 100). The latter seems to incorporate the many elements of seemingly fluid temporal-spatial relationships, and a profound sense of otherworldly abstraction anchored in the reality of its title object. It is a sharp contrast to the elegantly lyrical *Rock and Limpets*, 1969 (p. 102), made the same year.

The considerable body of non-nude work in the fifties includes *Old Typewriter*, 1951 (p. 52), not merely a pictorially

charming picture of decay, but a statement of time in which both natural and man-made objects are sharing the same fate, and even taking on similar forms. *Erosion*, 1959 (p. 43) and *Pilings under Cannery Row*, 1958 (pp. 80–81), though depicting very different subjects, closely share a deeper sense of the passage of time and the way in which the pattern of graphic geometry is caused by the unceasing cycle of the elements. A decade later, *Sea Palms*, 1968 (p. 75), would provide, through a technique similar to *Pilings under Cannery Row*, an even more emphatic and more powerfully abstracted sense of space-time.

Navigation Without Numbers, 1957 (pp. 30–31), named for the book in front of the window, seems in its surface elements an odd and ominous departure from Bullock's style, yet it, too, is a penetrating portrayal of time, derived on this unique occasion from the prophetic, rather than the historic. As it turned out, the photographer's prophesy of increasing physical distance between the two starkly insular figures came true, as though without numbers, they were unable to navigate toward each other.

In the mid 1950s an event occurred that was to influence profoundly not only public appreciation of photography, but also the efforts of subsequent generations of photographers. At the Museum of Modern Art in New York, Edward Steichen, then director of the Department of Photography, was in the midst of launching *The Family of Man*, an exhibition and publication of immense power drawn from the work of 273 photographers from sixty-eight countries. Two of Bullock's photographs were accepted for *The Family of Man*: *Child in Forest* and the one Steichen titled *Let There Be Light*, 1954 (pp. 104–105), the image used on the title page of the catalog. It was this photograph, certainly the least characteristic of Bullock's work, that was voted the most popular by the large crowds that saw the exhibition in Washington, D.C. Bullock would later speculate that it was because the solar flare resembled a cross and caused a religious empathy. *Child in Forest* would become what is probably his best-known image, though some public reaction caused him annoyance. Edna remembers how distressed Wynn was with people who interpreted the picture by thinking the child dead, molested, or representing a fallen statue, when he intended it to be a "virgin child in a virgin forest." Tragically, near the close of the twentieth century, our current social sensibilities make it difficult to prevent such macabre thoughts from touching at least the periphery of our visual consciousness.

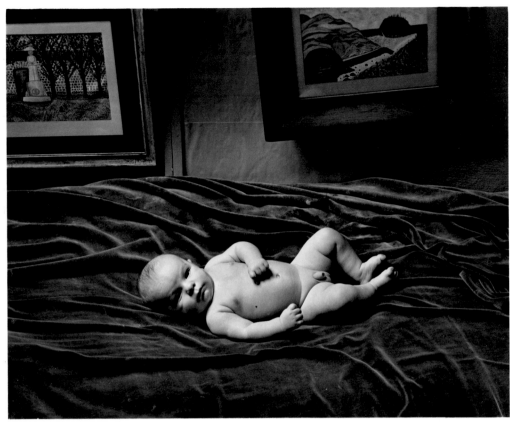

STEFAN, 1954

In 1959 Bullock left the concession at Fort Ord, though he was to continue free-lance commercial work for another nine years. The following year, his creative work began to revolve around the exploration of light itself as the subject of investigation rather than an unseen source of reflective illumination. As early as 1939 he had experimented with monochromatic light abstractions, but now he was to venture into color for the first time in his noncommercial, artistic work. It was a natural extension of his passion to explore light, facilitated by the gift of some broken optical glass from a lens destined for the Mount Palomar observatory. The glass provided the medium through which light could be inventively refracted, aided by a hammer with which Bullock could fracture the glass into more and more small pieces. By throwing the images out of focus, and manipulating both light source and the number, size, and positions of the glass fragments, he could achieve an infinite number of images of abstract color-light forms. What intrigued him was that he was now producing photographs of optical light, "purely plastic, creative forms." He wanted to make pictures of light for light's sake, images that would not be symbols of objects, but symbols of the radiant force that he had so loved all his life.

Toward the end of the sixties, Bullock embarked on what was destined to become his last search, which seems now like a summary of his experience and thought. As a young man he had become intrigued by the powers of light, and this took him on a

lifelong exploration of its many characters. Starting with partial reversal, then the "straight" photograph, the nude work, the illustration of nature through time-space, and the color light abstractions, he finally arrived at the negative image. This last work seemed to incorporate for him all the elements of his philosophical vision. It offered a new way to express the power of opposites. Borrowing a sentence from Paul Klee, "Nothing is thinkable without an opposite," he wrote. "I believe a thing is defined as much by what it is not as by what it is.... In the physical world there is no compression without tension, no convex without concave, no action without reaction. In the world of the mind there is no high without low, no near without far, no early without late." It is inevitable that this would have an important influence on his ability not just to see, in the passive sense, but to perceive; to train his mind to see opposites, to develop the brainpower to perceive full reversal. It would also serve to symbolize another dimension of opposites: "Two worlds exist on opposite sides of our sense organs: the inner world of ideas in our minds, and the outer world of events that stimulate our senses. Visual communication is based on the supposition that relationships between these two worlds can be established."

The purpose of this last exploration was to see more deeply into the essence of things, to reveal the whole by using opposites, and to uncover inner radiance, the light-force that emanates from and defines each event. For Bullock opposites were used to penetrate essence and uncover the light that he called "the mysterious force that makes up the universe." Light became for

him not only the means to visibility, but the force that "holds a rock together."

This last journey remained unfinished. Edna tells us that Wynn had hoped for a little more time "to see where this would take [him]." In 1973, suffering from an occasionally fibrillating heart and a severe depletion of energy, he was making his last photographs. Also in that year he was diagnosed with colonic cancer, underwent surgery, and began chemotherapy. By July of 1975, the cancer had spread to his liver. He accepted the prospect of his death as philosophically as he had lived his life, discussing it openly with the family, without depression, believing that "what comes from the mind does not die."

Toward the end of his life, he produced a series of studies of rocks and wood that seem overwhelmingly to be the products of another quest: the search for compelling evidence of living animacy in the inanimate, for the discovery of "faces," perhaps to "prove" his poetic notion that even the seemingly inanimate emanates radiant energy. It seems impossible to look at *Tree Trunk Lines*, 1972, without remembering Charles Laughton as Quasimodo in *The Hunchback of Notre Dame*, or *Untitled no. 16*, 1972, without remembering the benign ghost in a childhood dream. The negative prints and the faces were bound together as the components of a common expression of newfound freedom: to move away from the representational, toward a more abstract and intimate means of linking the mind of the artist with the mind of the viewer.

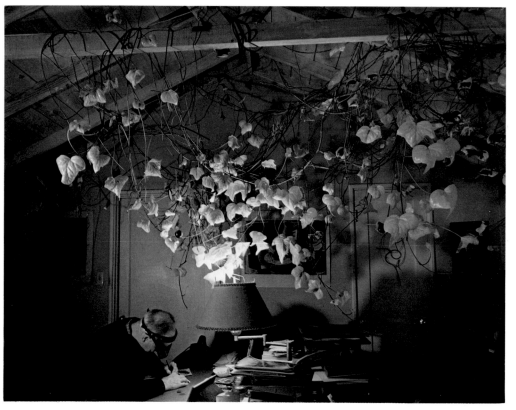

WYNN BULLOCK, C. 1968. Photograph by Phil Palmer.

Bullock's lifelong accretion of philosophical principles culminated in his distinction between reality and existence. Existence is the unknowable, the opposite of reality; it "encompasses the being of all things as they are in themselves beyond man's powers of perception and conception," whereas reality "represents the entire body of...experiences...knowledge, activities and products which develop from them."[10] It is a good example of the unity of opposites. On occasion Bullock drew from an endearing scientific license an enduring poetry in which the symbols are worthy of the universals they represent. Einstein would have smiled. There is no discernible single foundation from which Bullock's body of photographic lifework issues. Love of nature is too generalized and too romantic a criterion. Perhaps it is the power of the imperative to search: "How can you expand unless you search beyond what you are...searching to me is everything."[11]

Technique never did become, for Bullock, an end in itself. It always remained in its proper station, as servant to a deeper vision. It is precisely this disciplined, ranked relationship between technique and artistic substance that gave Bullock leave to take the exploratory risks that are truly a measure of the creative mind. "Creativity," he wrote in 1971, "is an ode to life. It is not a form of entertainment. It is a form of joy."[12]

For Bullock, the culmination of each of his many creative journeys was not the production of the artifact photograph-as-symbol; it was the arrival at a more profound state of understanding. Shortly before his death, Bullock was asked what he thought his own legacy would be. His answer was complex, outlining his beliefs, the principles he had developed, and the images themselves; finally, he added, "I believe that thought alone is a kind of legacy."

Bullock considered himself an intuitive photographer, by which he meant a contrast to one who deliberately, by intellectual forethought, brings the whole weight of his accumulated learning to bear on the making of each photograph. The philosophy was not created as a fundament to support each image; it was something that evolved out of, and together with, the making of his photographs.

We now know that two-thirds of the body's sense receptors are concentrated about the eyes, and so powerful therefore is the sense of vision that it has become the symbol, the metaphor, for the very act of understanding. Perhaps Bullock's most important legacy was the exhortation to risk and to create a journey from biological to spiritual vision. Not "I see, therefore I understand," but *cogito, ergo video*: "I think, therefore I see." In this volume he reveals to us an enchanted landscape, not of trees, rocks, and ocean, but of a mind and soul upon which was cast the magic spell of his own searching spirit.

Wynn Bullock died on November 16, 1975. Later, in a letter to Eileen Berger Kitzis, Edna wrote: "You may like to know he died at home, with me and his three daughters holding hands and holding his hands at the moment his spirit left his body. It was a peaceful and beautiful experience for us all." At 3:05 on that afternoon, Wynn Bullock passed from reality to existence.

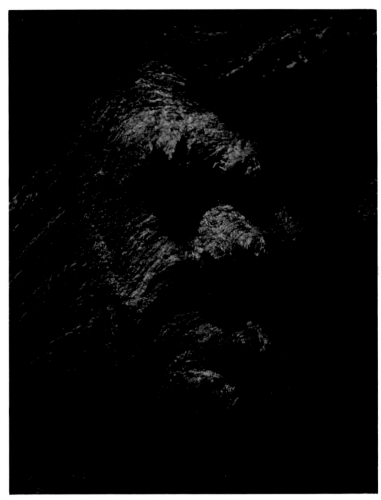

WOOD, 1973

6. Unpublished essay in Wynn Bullock Archive. Tucson: Center for Creative Photography, University of Arizona.

7. Margery Mann, "Wynn Bullock," *Popular Photography* (July 1970): 133.

8. Mimi Bullock. Unpublished essay, July 4, 1980.

9. Wynn Bullock to Eileen Berger Kitzis. Letter, March 13, 1971.

10. Barbara Bullock-Wilson, *Wynn Bullock, Photography—A Way of Life*. (New York: Morgan and Morgan, 1973): 39.

11. Film transcript, *Wynn Bullock: Photographer*, a film by Thom Tyson, 1975.

12. Wynn Bullock to Eileen Berger Kitzis. Letter, 1971.

1. Barbara Bullock-Wilson, "Wynn Bullock and Point Lobos." *The Photographic Journal* (October 1992).

2. Naomi Rosenblum, *A World History of Photography* (New York: Abbeville Press, 1989): 515.

3. "Ideas on photographs as symbols and the thing symbolized." Private paper, June 25, 1975.

4. "The Concepts and Principles of Wynn Bullock." Unpublished paper, 1970.

5. Wynn Bullock Archive, *Wynn Bullock*, Guide Series, no. 6 (Tucson: Center for Creative Photography, University of Arizona, 1982).

SELECTED BIBLIOGRAPHY

BOOKS ABOUT WYNN BULLOCK

Bullock, Barbara, with notes by Wynn Bullock. *Wynn Bullock*. San Francisco: Schrimshaw Press, 1971.

Bullock, Wynn. *The Photograph as Symbol*. California: The Artichoke Press, 1976.

Bullock-Wilson, Barbara. *Wynn Bullock: Photography—A Way of Life*. New York: Morgan and Morgan, 1973.

—, ed. *Wynn Bullock: Photographing the Nude*. Utah: Gibbs M. Smith, Inc., 1984.

Fuess, David. *Wynn Bullock*. The History of Photography series, vol. 4. New York: Aperture, Inc., 1976.

Mack, Richard. *The Widening Stream*. California: Peregrin Publications, 1965.

ARTICLES BY WYNN BULLOCK

"Portfolio." *Aperture* (October 1953): 20–29.

"Partial Reversal Line." *The Photographic Journal* (April 1955).

Article in *Creative Photography 1956*, 10–11. Lexington, Kentucky: Lexington Camera Club and Department of Art, University of Kentucky, 1956.

"Virtues of Large and Small Cameras are Evaluated." *Monterey Peninsula Herald's 11th Annual Art Edition* (November 3, 1956).

"Line Photography." *Medical and Biological Illustration* (October 1957): 75.

"Partial Reversal Line Photography." *Medical and Biological Illustration* (October 1957): 210.

"A New Concept in Photography." *Carmel Pacific Spectator Journal* (January 1958): 71–78.

"Time's Vital Relationship to Photography." *Contemporary Photography Magazine* (May–June 1960): 6–9.

Article in *The Photograph as Poetry*, 18–19. Pasadena, California: Pasadena Art Museum, 1960.

Article in *Three Photographers*, 5–8. Kalamazoo, Michigan: Kalamazoo Art Center Bulletin, February 1961.

Article in *Photographers on Photography*, edited by Nathan Lyons, 37–40. New Jersey: Prentice-Hall in collaboration with George Eastman House, 1966.

"The Fourth Dimension." *Photography Magazine* (September 1962): 42–49.

Article in "Nature Photography." *Pacific Discovery* (May–June 1963): 16–17.

Introduction to *Discovery: Inner and Outer Worlds, Portfolio II*. San Francisco: Friends of Photography, 1970.

Introduction to *Edward Weston Portfolio*. New York: Witkin-Berley, Witkin Gallery, 1971.

Introduction to *Wynn Bullock: Twenty Color Photographs*. Santa Clara: de Saisset Art Gallery and Museum, 1972.

"Wynn Bullock Nudes." In collaboration with Sir George F. Pollack, Bt., F.R.P.S.. *Creative Camera* (June 1969): 206–207.

ARTICLES ABOUT WYNN BULLOCK:

"A Tribute to a Dear Friend, 1977." *Photo-Image*, 1, no. 3 (1977): 2–47.

Auer, Michele, and Michel Auer. *Photographers Encylcopedia International: 1869 to the Present*. Switzerland: Editions Camera Obscura, 1985.

Badger, Gerry. "Wynn Bullock." *The Photographic Journal*, 115, no. 5 (May 1975): 206–213.

Baker, George. "Wynn Bullock and the Camera Eye." *The Argonaut Monthly* (June 1958): 7–10.

Booth, C. Weston. "Photographic Horizon." *U.S. Camera* (August 1946): 18–19, 55.

Bullock, Barbara. *Wynn Bullock*. San Francisco: San Francisco Museum of Art, 1969.

Bullock, Barbara and Jerry Uelsmann. "Wynn Bullock: Tracing Man's Roots In Nature." *Modern Photography* (May 1990): 84–89, 118, 120.

Bullock-Wilson, Barbara. "Wynn Bullock and Point Lobos: A Loving Tribute to Man and Place." *The Photographic Journal* (October 1992): 386–390.

Bullock-Wilson, Barbara. "Wynn Bullock and The Magic of Point Lobos." Special Edition of Alta Vista Magazine, *The Herald* (18 November 1990): 6–17.

Bush, George. "The Nude in Nature." *International Photo Technik*, no. 2 (1963): 113–115.

Bush, George. "Thoughts on Wynn Bullock: The Landscape—An Object of Philosophy." *International Photo Technik*, no. 1 (1961): 40–43.

Coke, Van Deren. "Creative Photography 1956." *Aperture* (January 1956): 12.

Coleman, A. D. *The Village Voice*. 29 July 1971.

Conrad, Donna. "A Gathering of Friends—An Interview with Edna Bullock." *Camera and Darkroom* (February 1993): 38–45.

Enyeart, James, ed. *Decade by Decade: Twentieth Century American Photography*. Boston: Bullfinch/Little Brown, 1989.

Fuess, David. "Wynn Bullock." *Carmel Pine Cone* (29 November 1975): 17.

Herz, Nat. "Wynn Bullock: A Critical Appreciation." *Infinity* (November 1961): cover, 4–10.

Hill, Paul, and Tom Cooper. "Camera, Interview—Wynn Bullock." *Camera*, no. 2 (February 1976): 38–48.

Hill, Paul and Tom Cooper. "Camera Interview—Wynn Bullock, Second Part." *Camera*, no. 3 (March 1976): 37–42.

Hill, Paul, and Tom Cooper. "Wynn Bullock," 313–337. *Dialogue with Photography*. New York: Farrar, Straus and Giroux, 1979.

Jackson, Ruth. "The Magic Eye of Wynn Bullock." *American West* (October 1989): 42–47, 78.

Jackson, Ruth. "Wynn Bullock, More Than Technique." *Camera 35* (1971): 42–48.

Johnson, Brooks, ed. *Photography Speaks: Sixty-Six Photographers on Their Art*, 84–85. New York: Aperture and the Chrysler Museum, 1989.

Lamb, Charles, and Cynthia Ludlow. "Wynn Bullock Archive." *Guide Series 6*. Tucson, Arizona: Center for Creative Photography, 1982.

Lawenski, Jorge. *The Naked and the Nude: A History of the Nude in Photographs, 1839 to the Present*. New York: Harmony Books, 1987.

Lyons, Nathan. "The Sense of Abstraction in Contemporary Photography." *Aperture* (April 1960): 111.

"Masters of Photography." *Darkroom* 7, no. 3. (May/June 1985): 38–44.

Naggar, Carole. "Bullock, Wynn, 1902–1975—États-Unis," 71–72. *Dictionnaire des Photographes.* France: Éditions du Seuil, 1982.

Ornitz, Don. "Natural Nude." *Photography Handbook*, no. 374 (date unknown): 42–44.

Parrella, Lew. "Wynn Bullock." *Creative Camera*, no. 87 (1958): 92–108.

Parrella, Lew. "Wynn Bullock." *U.S. Camera Annual* (1956): 223, 232–237.

Pollock, Sir George F. "The Art of Photography." *Amateur Photographer* (August 1966).

Rosenblum, Naomi. *A World History of Photography*, 516. New York: Abbeville Press, 1984.

Soblieszek, Robert A. *Masterpieces of Photography from the George Eastman House.* New York: George Eastman House, 1985.

Webb, William. *Henry and Friends, the California Years 1946–1977.* California: Capra Press, 1991.

Williams, Jonathan. "The Eyes of 3 Phantasts: Laughlin, Sommer, Bullock." *Aperture* (October 1961): 96–123.

Williams, Jonathan "Wynn Bullock." *Aperture*, no. 77 (1976): 34–37.

"Wynn Bullock—1902-1975." *Popular Photography* (March 1975).

Lewis, Eleanor ed. "Wynn Bullock, Photograph as Symbol," 7–21. *Darkroom*, Lustrum Press, Inc., 1977.

Wise, Kelly ed. "Wynn Bullock." *The Photographer's Choice*, 144–149. New York: Addison House, 1975.

"Wynn Bullock." *Photo-Image* 1, no. 1 (1976): 32–43.

"Wynn Bullock." *The Center for Creative Photography*, no. 2 (September 1976).

"Wynn Bullock." *Untitled 5*, The Friends of Photography (1973).

PHOTOGRAPHS IN PUBLISHED SOURCES

Adams, Ansel, and Nancy Newhall. *This Is the American Earth.* California: Sierra Club, 1960, p. 40.

American Children. New York: Museum of Modern Art, 1980, p. 38.

American Photographers. Kyoto: National Museum of Modern Art in Kyoto, 1989, pp. 16–26.

Chinese Influence on American West Coast Contemporary Photography, 16–21. Taiwan: Taiwan Museum of Art, 1988.

The Family of Man. New York: The Museum of Modern Art, 1955, title page and prologue page.

Gee, Helen. "The Fifties: A Reflection." *Photography Annual 1980/81*: 12.

"The Hermits of New Camaldoli." *St. Joseph's Magazine* (February 1960): cover and 12–15.

Hartwell, Carroll T. *Making a Collection.* New York: Aperture, 1984, pp. 69, 158.

Katzman, Louise. *Photography in California 1945–80.* San Francisco: San Francisco Museum of Art, 1984, pp. 36–37.

Le Guin, Ursula. *Wild Oats and Fireweed.* New York: Harper & Row, 1988.

Markowski, Gene. *The Art of Tomorow, Image and Illusion.* New Jersey: Prentice-Hall, 1984, pp. 4, 78, 89.

Miller, Henry. *Between Heaven and Hell.* Ed. Emil White. Big Sur: Emil White, Pub., 1961, pp. 96, 100, 101.

"Outstanding Achievement in Large Format Photography." *International Photos*, no. 2 (1959): 32–37.

Persistence of Beauty, Portfolio I. San Francisco: Friends of Photography, 1969.

The Photographic Tradition: The Weston Years. Monterey: Monterey Peninsula Museum of Art, 1989, pp. 33, 47.

Photographs of the Century. Worcester, Massachusetts: Worcester Art Museum, 1989.

Photography of the Fifties. Tucson, Arizona: Center for Creative Photography, 1983, pp. 89–91.

Picturing California: A Century of Photographic Genius. Oakland: Oakland Museum, 1989, pp. 79, 145.

Sandweiss, Martha A. *Masterworks of American Photography.* Texas: The Amon Carter Museum Collection, 1982, pp. 90, 127.

"The Sense of Abstraction: An Exhibition at The Museum of Modern Art." *Contemporary Photographer* (July–August 1960): 42–45.

Snyder, Gary. "Where We Are." *The American West* (July–August 1981).

"Space and Time." *Camera* (1967): 58.

Szarkowski, John. *American Landscapes.* New York: Museum of Modern Art, 1981, p. 63.

"Time and Space." *Way* (July–August 1975): 2–6.

"Visions of Beauty." *George Eastman House Collection.* Rochester, New York: George Eastman House, 1968, p. 64.

Wynn Bullock—Edward Steichen. Japan: Photo Gallery International, 1986.

GROUP EXHIBITIONS

1954 "Perceptions." San Francisco Museum of Art, San Francisco, California.

"Subjective Fotographie 2." State School of Arts and Crafts, Saarbrucken, Germany.

1955 "The Camera and the Artist." Fine Arts Society of San Diego, San Diego, California.

"Salut à la France: Fifty Years of Photography in the United States." Sponsored by the Photographic Department of the Museum of Modern Art, New York, shown at Musée d'Art Moderne de Paris, Paris, France.

"The Family of Man." The Museum of Modern Art, New York, New York.

1956 "Creative Photography 1956." University of Kentucky, Lexington, Kentucky.

"Infinity." Kurland Art Gallery, Pacific Grove, California.

1957 "Salon of International Photography." Photo Cine Club du Bal de Bièvre, France.

1958 "Subjective Fotographie 3." State School of Arts and Crafts, Saarbrucken, Germany.

"Photographs from the Museum's Collection." The Museum of Modern Art, New York, New York.

1959 "Art USA, 59." American Art Exposition, Inc., New York, New York.

"Tenth Anniversary Exhibition: Mid-Century Photography." George Eastman House, Rochester, New York.

"Photographic Exhibition: Love." Invitational exhibit, Limelight Gallery, New York, New York.

1960 "The Sense of Abstraction." The Museum of Modern Art, New York, New York.

"Photography in the Fine Arts II." Traveling exhibit, first shown at the Metropolitan Museum of Art, New York, New York.

"The Photograph as Poetry." Pasadena Museum of Art, Pasadena, California.

1961 "Twentieth Century American Art Exhibit." Kalamazoo Institute of Arts, Kalamazoo, Michigan.

"Three Photographers: Wynn Bullock, Aaron Siskind, David Vestal." Kalamazoo Institute of Arts, Kalamazoo, Michigan.

"Salon International du Portrait Photographique." Invitational exhibit, Bibliothèque Nationale, Paris, France.

"Photography as an Art." Invitational exhibit, Grand Palais des Champs Elysées, Paris, France.

"Arts and Images." International Center of Photography, Paris, France.

1962 "Photography USA: Nature and the Universe." Invitational exhibit, De Cordova Museum, Lincoln, Massachusetts.

Photographic exhibit, San Francisco Museum of Art, San Francisco, California.

"Towards Abstraction." Slide exhibit presented by Edward Steichen, The Museum of Modern Art, New York, New York.

"Vision and Division." Terrain Gallery, New York, New York. The Museum of Modern Art, New York, New York.

1963 "Photography in the Fine Arts III." Traveling exhibit first shown at Minneapolis Institute of Arts, Minneapolis, Minnesota.

Photographic exhibit, arranged by the Museum of Fine Arts, Boston, Massachusetts, shown at the Graduate School of Design, Harvard University, Cambridge, Massachusetts.

"Photography in the Fine Arts IV." Traveling exhibit first shown at the Metropolitan Museum of Art, New York, New York.

"Exhibition of Color Abstract Photographs." Division of Fine Arts, Fresno State College, Fresno, California.

1964 Photographic exhibit, Boston Arts Festival, Boston, Massachusetts.

"Photography 1964." Sponsored by and exhibited at the George Eastman House Museum of the New York Exposition, Syracuse, New York.

1965 "Photography in America 1950–1965." Yale University Art Gallery, New Haven, Connecticut.

1967 "Photography for Art in the Embassies." Cosponsored by Oakland Art Museum and the Focus Gallery. Exhibited at the Focus Gallery, San Francisco, California.

1968 "Invitational Exhibit." University of Florida, Gainesville, Florida.

"Invitational Exhibit." De Cordova Museum, Lincoln, Massachussetts.

"Trustees' Show." Friends of Photography Gallery, Carmel, California.

"Three-Man Show: Ansel Adams, Brett Weston, Wynn Bullock." Festival of Art, Ferris State College, Big Rapids, Wisconsin.

1971 Photographic exhibit, Light Gallery, New York, New York.

1972 "Beginnings." Invitational exhibit, Pennsylvania State College, University Park, Pennsylvania.

1973 "Art and Photography." Invitational exhibit, Museo Civico di Torino, Turin, Italy.

"Master Photographers: Ansel Adams, Wynn Bullock, Edward Weston." Pasadena Museum of Art, Pasadena, California.

1974 "Photography—USA." Bucharest International Fair, Bucharest, Romania.

"History of American Photography." Whitney Museum of American Art, New York, New York.

1976 "The Land." Victoria and Albert Museum, London, England.

1977 "Corroborations & Constructions." Chicago Center for Contemporary Photography, Chicago, Illinois.

1978 "From the Collection of Mr./Mrs. Arnold Gilbert." The Fine Arts Galleries and Perhelion Photographic Gallery, University of Wisconsin, Milwaukee, Wisconsin.

1979 "50 Photographs from a New York Private Collection." Sol B. Frank Memorial Gallery of Photography, Black and White Gallery, Miami Lakes, Florida.

1980 "Landmark 1980s in Photography." Keystone Gallery, Santa Barbara, California.

"Dan Berley Collection." Israel Museum, Jerusalem, Israel.

"Wynn and Edna Bullock." The Collector's Gallery, Pacific Grove, California.

1981 "Master Portraits of the 20th Century." Edwynn Halk Gallery, Chicago, Illinois.

1982 "Wynn and Edna Bullock." Exposures Gallery, Libertyville, Illinois.

"Wynn and Edna Bullock." Jeb Gallery, Providence, Rhode Island.

1983 "Three Photographers—Ansel Adams, Edward Weston and Wynn Bullock." Montana Historical Society, Helena, Montana.

"Sixth Anniversary Show: Wynn and Edna Bullock." Santa Fe, New Mexico.

"Four Dimensions, Wynn and Edna Bullock." Neikrug Gallery, New York, New York.

1984 "Photography in California, 1945–1980." Museum of Modern Art, San Francisco, California.

"Point Lobos: Place as Icon." Friends of Photography, Carmel, California.

1985 "Ansel Adams, Wynn Bullock, Edward Weston." Photo Gallery International, Tokyo, Japan.

"American Images, Photography 1945–1980." Barbican Gallery, London, England.

"Nude Variations: Wynn and Edna Bullock." Vision Gallery, San Francisco, California.

1986 "Wynn Bullock—Edward Steichen." Photo Gallery International, Tokyo, Japan.

"The Monterey Photographic Tradition: The Weston Years." Monterey Peninsula Museum of Art, Monterey, California.

"In Love with the Universe: Ralph Steiner Looks at Photography." Hood Museum of Art, Dartmouth College, Hanover, New Hampshire.

1987 "Wynn and Edna Bullock, A Way of Life." Olive Hyde Art Gallery, Fremont, California.

"12th Annual Photography Auction & Exhibition." Museum of Art, University of Oregon, Eugene, Oregon.

"Eye of the Writer." Richmond Art Center, Richmond, California.

"Photography and Art, 1946–86." Los Angeles County Museum of Art, Los Angeles, California.

"Twentieth Anniversary Exhibition." Friends of Photography, Carmel, California.

1988 "The Influence of Chinese Art on the Recent Art of the American West Coast." Taiwan Museum of Art, Taichung, Taiwan, R.O.C.

"Octobre des Arts." Musée Saint Pierre, Lyon, France.

1989 "Earthscape." Expo 90 Photo Museum, Tokyo, Japan.

"American Photographers." Shoto Museum of Art, Tokyo, Japan.

1990 "Let There Be Light, Edna and Wynn Bullock." Foto Galerie, Chinoteague, Virginia.

"Picturing California: A Century of Photographic Genius." First exhibited at Oakland Museum, Oakland, California.

1992 "The Classic Nude." Silver Image Gallery, Seattle, Washington.

Group Exhibition, Imagery Gallery, Lancaster, Ohio.

1993 "Faces and Figures—The Photographs of Wynn and Edna Bullock." Featured exhibit of Fotofeis 1993, Talbot Rice Gallery, University of Edinburgh, Scotland.

"Wynn and Edna Bullock—A Retrospective Exhibit." Museum of Art, University of Oregon, Eugene, Oregon.

"Wynn and Edna Bullock." The Halstead Gallery, Birmingham, Michigan.

ONE-PERSON EXHIBITIONS

1941 Los Angeles County Museum of Art, Los Angeles, California.

1947 Santa Barbara Museum of Art, Santa Barbara, California.

1954 University of California, Department of Art, Los Angeles, California.

1955 Limelight Gallery, New York, New York.

1956 Cherry Foundation Art Gallery, Carmel, California.
M. H. de Young Museum, San Francisco, California.
George Eastman House, Rochester, New York.

1957 Bulawayo, Southern Rhodesia.
The Johannesburg Photographic and Cine Society, South Africa.
Oakland Public Museum, Oakland, California.
Photographia de Assouacao dos Velhos, Pietermaritzburg and Lorenco Marques, Portugese South Africa.

1958 Art Center of Czechoslovakia, Prague, Czechoslovakia.

1959 Gull Pacific Arts Gallery, Richmond, California.

1960 Monterey Peninsula College, Monterey, California.
Princeton University, Graphics Arts Department, Princeton, New Jersey.

1961 Fine Arts Galerie Pierre Vanderborght, Brussels, Belgium.
Icon Gallery, Venice, California.

1962 Carl Siembab Gallery, Boston, Massachusetts.
Cheney Cowles Memorial Art Gallery, Spokane, Washington.

1963 Toren Art Gallery, San Francisco, California.

1964 University of Florida, Gainesville, Florida.

1966 Foothill College, Los Altos, California.
Cuyahoga Community College, Cleveland, Ohio.

1967 Jacksonville Museum of Art, Jacksonville, Florida.
Reed College, Portland, Oregon.

1968 Camera Work Gallery, Newport Beach, California.
Canton Jewish Center, Canton, Ohio.
Melrose Library, Melrose, Massachusetts.
Pacific Grove Art Museum, Pacific Grove, California.
Rhode Island School of Design, Providence, Rhode Island.
University of St. Thomas, Media Center, Houston, Texas.

1969 Illinois Institute of Technology, Institute of Design, Chicago, Illinois.
Phoenix College, Phoenix, Arizona.
San Francisco Museum of Art, San Francisco, California.
Skidmore College, Saratoga Springs, New York.
St. Mary's College, Notre Dame, Indiana.
University of Iowa, Iowa City, Iowa.
University of North Carolina, Greensboro, North Carolina.
University of the South, Sewanee, Tennessee.
University of Washington, Seattle, Washington.
Witkin Gallery, New York, New York.

1970 Amon Carter Museum of Western Art, Fort Worth, Texas.
Central Missouri State, Warrensburg, Missouri.
Colorado Springs Fine Arts Center, Colorado Springs, Colorado.
Long Island University, Greenvale, New York.
Minneapolis Institute of Art, Minneapolis, Minnesota.
Rice University, Houston, Texas.
Santa Barbara Museum of Art, Santa Barbara, California.
Temple University, Philadelphia, Pennsylvania.

1971 Bathhouse Gallery, Milwaukee, Wisconsin.
Columbia College, Department of Art, Chicago, Illinois.
The 831 Gallery, Birmingham, Michigan.
Friends of Photography Gallery, Carmel, California.
Hiram College, Hiram, Ohio.
Maryland Institute of Art, Baltimore, Maryland.
Moorehead State College, Moorehead, Minnesota.

Museum of New Mexico, Albuquerque, New Mexico.
University of Georgia, Athens, Georgia.

1972 Limited Image Gallery, Chicago, Illinois.
de Saisset Art Gallery, University of Santa Clara, Santa Clara, California.
North Shore Community College, Beverly, Massachusetts.
Ohio Northern University, Ada, Ohio.
Pennsylvania State University, University Park, Pennsylvania.
Shado Gallery, Oregon City, Oregon.
United States Information Agency, traveling exhibit first exhibited in Washington, D.C.

1973 Light Gallery, New York, New York.
Pasadena Museum of Art, Pasadena, California.
Bibliothèque Nationale, Paris, France.
Edison University, Salt Lake City, Utah.
Ohio University, Athens, Ohio.
University of Colorado, Boulder, Colorado.

1974 Madison Art Center, Madison, Wisconsin.
Focus Gallery, San Francisco, California.
Museum of Art, University of Oregon, Eugene, Oregon.
Silver Image Gallery, Seattle, Washington.
Galerie du Château d'Eau, Toulouse, France.

1975 Shadai Gallery, Tokyo College of Photography, Tokyo, Japan.
Shunju Gallery, Tokyo, Japan.
Tokyo University, Tokyo, Japan.
Royal Photographic Society, London, England.
Shado Gallery, Oregon City, Oregon.
Center for Photographic Studies, Louisville, Kentucky.

1976 G. Ray Hawkins Gallery, Los Angeles, California.
Metropolitan Museum of Art, New York, New York.
The Art Institute of Chicago, Chicago, Illinois.
de Saisset Art Gallery, University of Santa Clara, Santa Clara, California.
Monterey Peninsula Museum of Art, Monterey, California.
Déjà Vu Gallery, Toronto, Canada.
San Francisco Museum of Art, San Francisco, California.

1977 Photographers' Gallery & Workshop, South Yarra, Australia.
Silver Image Gallery, Ohio State University, Columbus, Ohio.

1978 Tokyo Designers Space, Tokyo, Japan.
Pallas Photographic Gallery, Chicago, Illinois.
Galerie Fiolet, Amsterdam, Netherlands.
Silver Image Gallery, Seattle, Washington.

1979 Cody's Gallery, Berkeley, California.
Worcester Art Museum, Worcester, Massachussetts.
de Saisset Art Gallery, University of Santa Clara, Santa Clara, California.

1980 Photo Gallery International, Tokyo, Japan.
Metropolitan Museum and Art Center, Miami, Florida.
Eclipse Gallery, Boulder, Colorado.

1981 Shadai Gallery, Tokyo Institute of Polytechnics, Tokyo, Japan.

1982 Collectors, Pacific Grove, California.
Photography West Gallery, Carmel, California.

1985 Bank of Arizona, Phoenix, Arizona.

1988 La Réverbère Galerie Photographique, Lyon, France.

1989 The Photographic Center, Carmel, California.

1992 Center for Photographic Arts, Carmel, California.

THIS PUBLICATION IS MADE POSSIBLE THROUGH
THE GENEROUS GIFT OF DYAN AND ROGER URBAN
AS WELL AS CONTRIBUTIONS FROM
VIRGINIA ADAMS, ARTHUR JOEL BELL,
MORRIE CAMHI, RICHARD L. MENSCHEL, AND
PHOTO GALLERY INTERNATIONAL/SATA CORPORATION.

ACKNOWLEDGMENTS

Thanks are due to the following people and institutions who have been instrumental in preparing *The Enchanted Landscape*: Edna Bullock, Barbara Bullock-Wilson, Gene Bullock-Wilson, Lynne Harrington-Bullock, Gilbert Harrington, Mimi Horner, Morley Baer, Ruth Bernhard, Dave Bohn, Jim Hill, Sue Hoffman, Chris Johnson, Eileen Kitzis, Mike Mandel, Joan Murray, Adele Rowland, Thom Sempere, Thom Tyson, Todd Walker, Amy Rule at the Center for Creative Photography, and the San Francisco Museum of Modern Art.

A limited edition consisting of one hundred original prints of twelve different images, printed by or under the supervision of Wynn Bullock, and accompanied by a slipcased edition of the monograph, is available from Aperture's Burden Gallery, 20 East 23rd Street, New York, New York 10010. Call (212) 505-5555, or fax (212) 979-7759, for further information.

An exhibition of one hundred vintage prints printed by Wynn Bullock will travel nationally and internationally. For more information contact the Burden Gallery, 20 East 23rd Street, New York, New York 10010; telephone (212) 505-5555.

Library of Congress Catalog Card Number: 93-71081
Hardcover ISBN: 0-89381-546-2

Book design by Wendy Byrne. Jacket design by Peter Bradford. Printed and bound by Arti Grafiche Motta SpA, Milan, Italy. Duotone separations by Robert Hennessey.

The staff at Aperture for *The Enchanted Landscape* is: Michael E. Hoffman, Executive Director; Jane D. Marsching, Editor; Michael Sand, Managing Editor; Stevan Baron, Production Director; Sandy Greve, Production Associate.

Aperture Foundation publishes a periodical, books, and portfolios of fine photography to communicate with serious photographers and creative people everywhere. A complete catalog is available upon request. Address: 20 East 23rd Street, New York, New York 10010.

First edition
10 9 8 7 6 5 4 3 2 1